IMAGES
of America

IRISH DENVER

ON THE COVER: High above the 1912 Dedication Day crowds, Msgr. Hugh McMenamin and four key laymen watched Card. John Farley bless the twin spires of Denver's Cathedral of the Immaculate Conception. (Courtesy of Denver Public Library.)

IMAGES
of America

IRISH DENVER

Dennis Gallagher, Thomas Jacob Noel,
and James Patrick Walsh

ARCADIA
PUBLISHING

Published by Arcadia Publishing
Charleston, South Carolina

Printed in the United States of America

Library of Congress Control Number: 2011938165

For all general information, please contact Arcadia Publishing:
Telephone 843-853-2070
Fax 843-853-0044
E-mail sales@arcadiapublishing.com
For customer service and orders:
Toll-Free 1-888-313-2665

Visit us on the Internet at www.arcadiapublishing.com

Welcome, fellow readers, to this first pictorial overview of Irish Coloradans. Happily, the once struggling "fighting Irish" have turned into much more peaceful, constructive members—and often leaders— here in the Highest State.

Fortunately, this book has found well-qualified authors. Dennis Joseph Gallagher, a longtime professor of classics, persuasion, and speech at Regis University, has been an outstanding faculty member whose courses have included 17 years of summer programs in Ireland for our Regis students. Dennis participates in a wide range of Celtic activities, not to mention his long and distinguished political career.

Prof. Thomas Jacob Noel also once co-taught courses at Regis with Professor Gallagher before moving on to the University of Colorado Denver. Tom's many books, including a history of the Archdiocese of Denver and various immigrant groups, have become valuable resources, as this book will be.

Dr. James Patrick Walsh, whose PhD dissertation focuses on Leadville's Irish community and labor leaders, likewise teaches at Regis as well as CU-Denver. Jim also stages popular community theater, through the Romero Troupe that he founded and named for martyred Salvadoran archbishop Oscar Romero.

I am pleased to see a chapter on the role of the church in Irish life. The many contributions of Irish laywomen and laymen, sisters, priests, and teachers are well worth celebrating. At Regis, for instance, we have grown from a small college into a major university with eight campuses in Colorado and Nevada serving more than 14,000 students.

As my own family has deep roots in Ballymote, County Sligo, I am happy to bestow my blessings upon this book and its readers.

Dominus Vobiscum,

Michael J. Sheeran, SJ
President, Regis University

CONTENTS

ACKNOWLEDGMENTS

Special thanks to Daniel Patrick, Meaghan and Tim Gallagher, Vi Noel, Gabriela Flora, and Lily Flora-Walsh. Our greatest thanks go to Blake Thomas Magner, who served as book master.

Coi Gehrig, Denver Public Library's crackerjack photo specialist in the Western History Department, was heaven-sent help, as were all the other angels at the library, especially Wendell Cox, Bruce Hanson, James Jeffries, and Jim Kroll. Likewise, thank to Becky Lintz and the crew at the Colorado Historical Society, laboring under a new name, History Colorado. Regis University Library and Public Relations; St. Joseph Hospital; Janice Fox and Nancy Manly at Lake County Public Library; Karyl Klein, archivist at the Archdiocese of Denver; John Gleason at the Denver Catholic Register; and Richard and Maureen Caldwell and Michael Foley of the Denver St. Patrick's Day Parade Committee were among the many providing marvelous assistance. Thanks as well to Pat McCullough at the Celtic Connection.

Many, many wonderful people responded to our public pleas for images. Alas, the limited scope of this book meant we had to exclude a lot of fine photographs and great Irish stories and personalities.

We hope we have not forgotten you on a long list of thank-yous. Our hats are off to the Ancient Order of Hibernians; James Baca and the Denver Catholic Register; Ron Berkeley of Berkeley Lainson Studios; Wesley A. Brown; Catherine Byrne; Mary Ann Casey; the Colorado Irish Festival; Henry Davis; Loretta Horrigan Davis; Dave O'Shea Dawkins; Regis Donovan; Debra Faulkner; Jody Feely; the Rich Feely family; Kathleen Fitzsimmons; Charles Gallagher; Maureen Hendricks; Ann Hession; Leo Hobbs; the Irwin family; the George Kennedy family; Nita Kennedy; the Karyl Klein family; Barbara Lucy Klein; the Ken Hannon Larson family; Ken Lombardi; Kelly Mansfield; Aidan McGuire; Gwen Mayer; Nancy and Paul McMenaman; Jim McNally; the Kevin, Mary, and Sean McNicholas family; the McTaggert Dancers; Michael Collins Pipe Band; Mitch and Maggie Morrissey; John Nallen; Jack Natterman; John Nielson; Frank Nortnik; the Sandy Oliver family; the David O'Shea-Dawkins family; Bill Owens; Tom Quinn; Rich Rodgers; Mary and Lisa Rogers; Gully Stanford; the Joanne Healy Sesson family; the Jeanette Shea family; Fr. Michael Sheeran, SJ; the Barbara Smith family; Dorothy Stewart; John Stewart; Patsy Stockton; Bridget Stoklosa; Barry Sweeney; Rich Grant and Visit Denver: The Convention and Visitor Bureau; Lou Walsh of the Irish Fellowship; Roger Whitacre; and Christian Whitney. We were not able to include everyone in our book but are eternally grateful to all of you for opening up your photo albums and memories.

Next time we see you, we're buying!

—Dennis Gallagher, Tom Noel, and Jim Walsh

INTRODUCTION

Although it cannot rival the size of Irish enclaves in cities such as New York, Chicago, Boston, Philadelphia, or San Francisco, Denver's Irish community has had a significant impact on the history of the city and the state.

The earliest Irish residents in Colorado, however, were a largely rural population. The 1870 and 1880 federal census reports show Irish miners in Gilpin and Lake Counties, Irish railroad workers in isolated construction sites across the state, Irish soldiers serving in scattered forts, and Irish women working nearly everywhere as domestic servants and seamstresses. Irish priests, such as Fr. Henry Robinson, roamed throughout the mining districts during the 1860s and 1870s performing baptisms and marriages.

In the 1870 census for Denver, 60 percent of Irish men are listed as common laborers, while 70 percent of single Irish women are listed as domestic servants. Hibernians in early Colorado lifted, hauled, dug, fought, cleaned, fed, and scrubbed. They were the sweat, blood, and muscle of an expanding American empire, extracting precious metals, laying new roads of iron and steel, and tending to the needs of the privileged.

Most of early Colorado's Irish miners migrated through other mining communities, such as the copper mines of the Beara Peninsula in western County Cork, the Pennsylvania anthracite coal region, and the copper country in Michigan's Upper Peninsula. Others mined in regions in Scotland and England before moving to Colorado. Many of Colorado's Celts came via Canada.

The silver boom in Leadville in 1877 resulted in a river of Irish migrants moving from Denver and elsewhere into the Colorado high country. During this time, the Irish "capital" of Colorado moved from Gilpin County to Lake County (Leadville). By 1880, at least 2,100 Irish-born persons lived in Lake County, as did nearly as many Irish Americans. Until 1900, Leadville was as Irish as any town in the American West, representing nearly 20 percent of its population. Oscar Wilde famously spoke in the Tabor Opera House in Leadville. Irish nationalists such as Michael Davitt visited Denver and Leadville to raise funds for the Irish Land League. Colorado was considered a fundraising gold mine for Irish nationalists. As early as 1881, the Cloud City Irish gave more to Davitt's Land League than every city in America except Chicago and Philadelphia.

Colorado experienced several bitter labor struggles. In 1880, Dublin-born Michael Mooney led a walkout involving as many as 5,000 Leadville miners demanding better safety conditions and a living wage of $4 a day. When Leadville's business community convinced Governor Pitkin to declare martial law and send Colorado National Guardsmen to Leadville to break the strike, Mooney was nearly lynched by vigilantes. During the strike, Mooney worked with Denver's Dublin-born labor leader Joseph Murray, an Irish nationalist who had been born into poverty and became an officer in the 69th New York regiment, also known as the "Irish Brigade."

Sixteen years later, Irish miners in Leadville led another walkout. This strike lasted nine months and was led by the Denver-based Western Federation of Miners and their Irish-born president, Edward Boyce. Once again, the Colorado National Guard was called in to break the strike. Several miners were killed in 1896 when a radical element within the miners' union attacked the Coronado and Robert Emmet Mines that had been reopened with replacement workers. The dead Irish miners were buried in secret graves.

Other disputes soon followed. Hibernian miners led two major Western Federation of Miners strikes in Cripple Creek. Irish American John C. Sullivan led the Denver-based Colorado Federation of Labor during the 1903–1904 Cripple Creek strike. Mother Mary Jones was jailed in Trinidad, Colorado, when she became active in support of the striking coal miners and their families during the time of the Ludlow Massacre.

In the beginning of the 20th century, following the collapse of the silver market, thousands of Irish and Irish Americans began to migrate to Cripple Creek and Denver. In 1910, roughly 63 percent of the Irish-born population of Colorado lived in the urban corridor "front range" stretching from Fort Collins to Pueblo. A full 44 percent of Irish-born Coloradans lived in the Denver metro area in 1910. The two-mile-high Leadville Irish moved a mile down to join the Mile High Irish in Denver. Among these were Margaret Tobin Brown, also known as Molly Brown, and mine owners like John Campion. The Leadville Irish became the Denver Irish.

The earliest Irish enclaves in Denver were concentrated near the railroad tracks that followed the South Platte River. Heavy concentrations of Irish lived in areas like Baker, Auraria, Highland, the South Platte River "Bottoms," Curtis Park, Elyria, Swansea, and Globeville. Many Irish women were among the Sisters of Charity of Leavenworth, the Sisters of Mercy, and the Sisters of Loretto, who served the needy and built hospitals across the state. Denver churches, such as St. Joseph's, St. Leo's, St. Patrick's, Sacred Heart, Annunciation, and the Cathedral of the Immaculate Conception, all began with heavily Irish congregations. Much Celtic conviviality also revolved around that other Irish spiritual center—the saloon.

The Irish soon worked their way into the middle class. They migrated into prestigious Denver neighborhoods, such as Capitol Hill, and moved into more respectable occupations, such as police officer, fireman, nurse, teacher, and business owner.

The Denver Hibernians built many ethnic organizations. Irish militias, such as the Mulligan Guard in Denver and the Wolfe Tone Guard in Leadville, served both a protective purpose against anti-Irish elements and as a tool of respectability. Irish and Catholic organizations, such as the Ancient Order of Hibernians, the Knights of Columbus, and the Daughters of Erin, created opportunities for ethnic fellowship, service, and camaraderie.

Irish nationalists, who led the long struggle to gain independence from England, found many Colorado supporters. As early as the 1870s and 1880s, several Denver Fenians, Irishmen fighting to establish an independent Irish Republic, fought in Canada in a short-lived attempt to "liberate" it from English rule. Other Denver Hibernians were fighting against England in the Boer War in South Africa. The Denver Fenians began a tradition of Mile High Irish nationalism that existed in Colorado well into the 20th century.

At times, sectarian tensions made their way into Denver. On St. Patrick's Day in 1900, Irish residents noticed a 20-foot orange flag atop city hall. After a tense standoff, a fireman hauled the flag down, and, according to the *Denver Times*, a "war dance was executed around its remains." The Mile High Irish were also active in challenging offensive stage depictions of the Irish as ape-like creatures and drunks.

Like other major American cities, Denver had a strong Irish political presence. Families like the Carrigans, Currigans, and McNichols have served the state and city in many capacities, as have renowned early politicians such as John A. Carroll, Edward P. Costigan, Edward Keating, Robert Morris, and Thomas Patterson. More recently, figures such as Joan Fitzgerald, Dennis Gallagher, Cary Kennedy, Mitch Morrissey, Mary Mullarkey, and Bill Owens have continued this long tradition of Irish political involvement.

Since the days when figures like Michael Davitt and Oscar Wilde visited Colorado, Denver has continued to host important Irish figures. In 1919, Irish president Eamon De Valera visited Denver, raising support for what would become an independent Irish republic. Robert and Ben Briscoe, Jewish father-and-son lord mayors of Dublin, both visited the Mile High City, as did Irish president Mary McAleese in 2006.

Today, Irish culture can be found everywhere in Denver. The annual Colorado Irish Festival draws tens of thousands, while the St. Patrick's parade boasts of being the second largest in the nation. Irish businesses are too numerous to count, and the region even has its own monthly Celtic newspaper. Step dancers, pubs, and Celtic musicians live in every corner of Denver and across the state, giving Colorado a deep, rich, and colorful Celtic flavor.

One

Gold, Guns, and Gandy Dancers
Hibernians in Early Colorado

Colorado's earliest Irish communities were located on the fringes of an expanding American empire. The 1870 federal census lists 1,614 Irish-born residents in Colorado. Just 256 of them lived in the city of Denver. Some 60 percent are listed on the census as common laborers. Among single Irish women in Denver at that time, 70 percent are listed as domestic servants.

Irish women in early Colorado were depicted in newspapers as unmannered, violent, and mentally unstable. One *Rocky Mountain News* article, for example, on October 21, 1873, described a "bevy of infuriate Irish girls, three in number, entered the *News* counting room last evening with the intention of storming the establishment." Irish women had very limited opportunities for income. Aside from working as domestics, they served as laundresses, seamstresses, and servants in hotels, saloons, and boardinghouses.

The state's early Irish population was predominately male and working class, with the vast majority employed as miners, railroad workers, and soldiers. These occupations often required them to live in remote areas—mining camps, forts, and makeshift railroad tent colonies.

Of the 265 Irish-born miners living in 1870 Colorado, most resided in Gilpin County, where Nevadaville served as a kind of Paddytown. Another 234 Irish railroad workers were concentrated along the eastern plains, building Denver's first railroad. A total of 55 Irish soldiers are listed in the 1870 census at places like Fort Lyons and Fort Sedgwick. These early Sons of Erin labored in lonely conditions across the Great American Desert.

The late 1870s silver boom in Leadville led to a flood of Irish migrants into the two-mile high "Cloud City." By 1880, as many as 5,000 Irish-born and Irish Americans lived in Lake County. When the silver market collapsed in the 1890s, many moved to gold fields of Cripple Creek and Victor. Others moved to Denver and became a vital part of that city's growing Irish community.

By 1910, nearly half of Colorado's Irish-born population lived in Denver. Hibernian working-class muscle helped establish Denver as the hub city of the Rocky Mountains. While many found a better life in the West, others lie in unmarked graves in mining camps and prairie railroad hamlets.

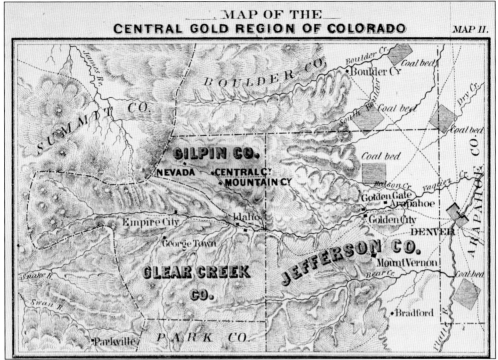

This 1863 map of the central gold region shows Nevada (also known as Nevadaville), Central City, and Mountain City as the early 1860s hub of the gold rush. At that time, the area had more people than Denver or any other area. It is a ghostly region today, with only Central City surviving as a post office town. (Wesley A. Brown collection.)

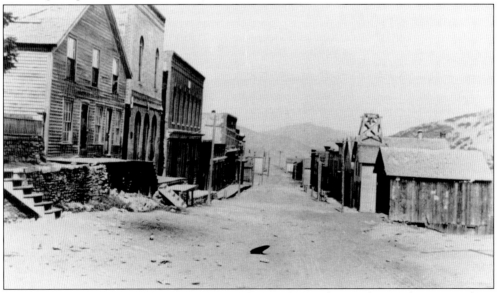

Nevadaville, Colorado's first Paddy Camp, lay three miles southwest of Central City. Nearly 10 percent of that town's population in 1870 came from the Emerald Isle. This gold-mining town peaked in 1880 with a population of 1,048 but had become a virtual ghost town by 1930, when it had two residents. (Thomas J. Noel collection.)

At the Hubert Mine in Nevadaville, workers rode the ore buckets back and forth to their underground gold diggings. Although dangerous, bucket riding was the fastest and easiest way into and out of the mines sunk deep into the Colorado earth. Like other miners, the Celts took their chances and often suffered injury or death while working the mines. (Colorado Historical Society.)

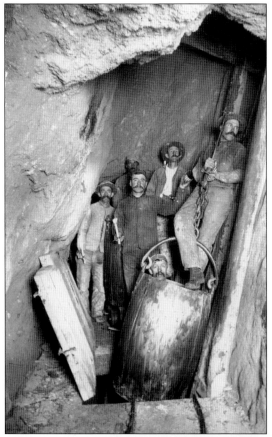

The Mary Murphy Mine near Cripple Creek attracted many Hibernians from across North America. The Cripple Creek and Victor area was heavily Irish, second only to Leadville. Two important strikes took place in Cripple Creek and Victor, one in 1894 and the other in 1903–1904. Both were led by Irish miners. During the 1894 strike, Colorado's populist governor Davis Waite used the Colorado National Guard to protect striking miners from vigilantes. (Lisa Rogers family photograph collection.)

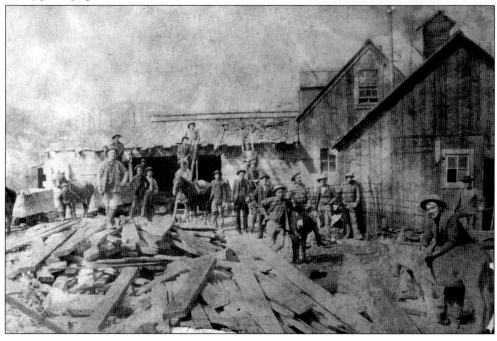

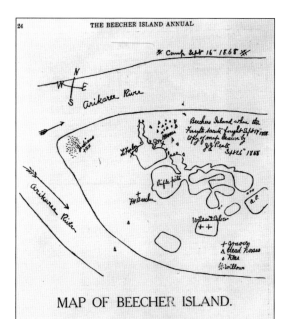

✗ Camp Sept 16" 1868 ✗

N
W · E
S Arikaree River

Beecher Island when the
Forsyth scouts fought Sept 17 1868
copy of map drawn by
J J Peate
Sept 26" 1868

Rifle pits

FHBeecher

Arickaree River

Wilson T Leber
++

+ graves
▲ dead horses
○ rifles
❀ willows

MAP OF BEECHER ISLAND.

The above map is reproduced from a copy drawn by J. J. Peate, of the Relief Expedition, at the time Forsyth and his scouts were rescued by Col. Carpenter's command.

The Island appears today as it did then excepting that the south channel of the river is closed and the trees and improvements, including the monument, appear as the Association has placed them.

Many Irishmen joined the Army as a ticket to the West and its golden opportunities. The "fighting Irish" saw a great deal of action in the Indian Wars and the Civil War but were often invisible as they filled the lower ranks. The forgotten hero of the Battle of Beecher Island, for instance, was an Irish scout named Jack Donovan. Roman Nose and some 250 Cheyenne warriors ambushed Col. George Forsythe and his 48 men on September 19, 1868, near the Colorado-Kansas Border in Yuma County. Forsyth was wounded and many of his men killed as they retreated to an island in the middle of the Arickaree River. Donovan volunteered to sneak through the Cheyenne lines and head for Fort Wallace 100 miles away. When darkness came, he and a buddy exchanged their boots for the moccasins of a dead Cheyenne and began the perilous journey. Six days later, Donovan returned with reinforcements to save Captain Forsythe and his surviving men. Yet, the battle is named for Lt. Frederick Beecher, who was killed in the battle, rather than for the lowly scout who saved the day. (Both, Denver Public Library and Ken Larson family.)

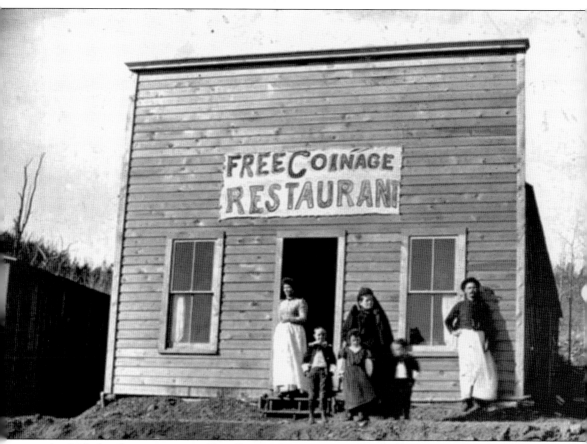

An Irish family poses next to Free Coinage Restaurant in Leadville. Women found work in restaurants, saloons, and boardinghouses where miners welcomed a woman's skills in providing food and board. (Sandy Oliver family photograph, Jim Walsh collection.)

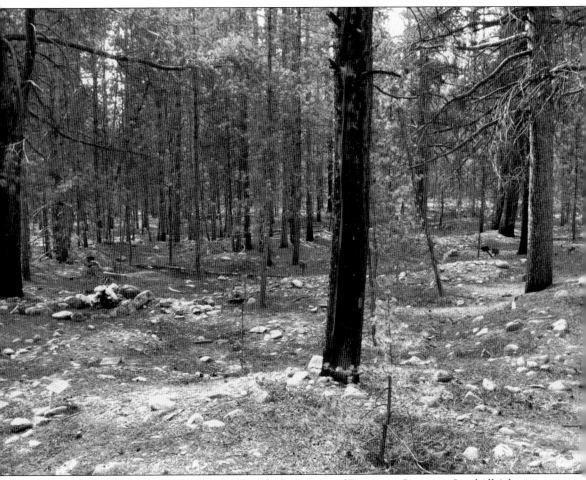

Over 1,500 people are buried in the Old Catholic Section of Evergreen Cemetery, Leadville's largest burial ground. In this pauper section, unmarked graves stretch for acres through an evergreen forest, revealing the human tragedy of early mining camps. Two-thirds of the known burials in the Free Section have Irish surnames. The average age of death is 23. Pneumonia was the leading cause of death, followed by mining accidents and murder. (Jim Walsh.)

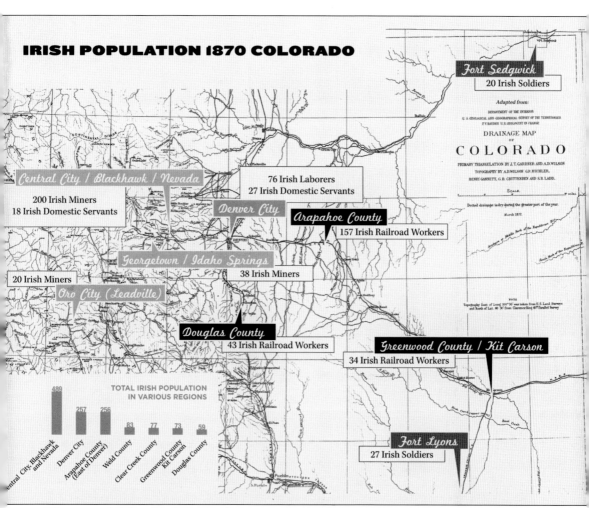

IRISH POPULATION 1870 COLORADO

Fort Sedgwick
20 Irish Soldiers

Adapted from:
DEPARTMENT OF THE INTERIOR
U. S. GEOLOGICAL AND GEOGRAPHICAL SURVEY OF THE TERRITORIES
J. V. HAYDEN U.S. GEOLOGIST IN CHARGE

DRAINAGE MAP
OF
COLORADO

PRIMARY TRIANGULATION BY J. T. GARDNER AND A. D. WILSON
TOPOGRAPHY BY A. D. WILSON G. R. BECHLER,
HENRY GANNETT, G. B. CHITTENDEN AND S. B. LADD.

Central City / Blackhawk / Nevada
200 Irish Miners
18 Irish Domestic Servants

76 Irish Laborers
27 Irish Domestic Servants

Denver City

Arapahoe County
157 Irish Railroad Workers

Georgetown / Idaho Springs
38 Irish Miners

20 Irish Miners

Oro City (Leadville)

Douglas County
43 Irish Railroad Workers

Greenwood County / Kit Carson
34 Irish Railroad Workers

TOTAL IRISH POPULATION
IN VARIOUS REGIONS

489
257
256
83
77
73
59

Central City, Blackhawk and Nevada
Denver City
Arapahoe County (East of Denver)
Weld County
Clear Creek County
Greenwood County Kit Carson
Douglas County

Fort Lyons
27 Irish Soldiers

This map of Colorado's Irish population in 1870 highlights miners in Gilpin County, laborers and domestic workers in Denver, railroad workers in the eastern plains, and soldiers in forts along the South Platte and Arkansas Rivers. The vast majority of Irish persons in early Colorado lived in remote regions of the state. (Denver Public Library Western History Collection, 1870 map of Colorado; additions by Rich Rodger.)

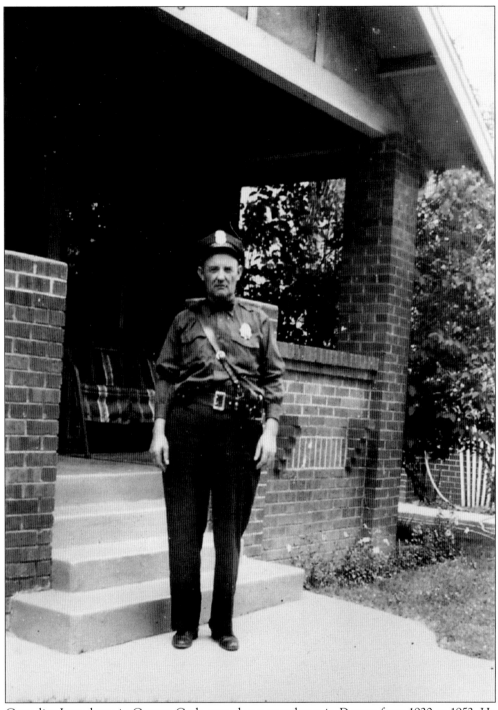

Cornelius Lucy, born in County Cork, served as a patrolman in Denver from 1920 to 1952. He was one of the last of Denver's many Irish-born police officers. Lucy recalled in a 1988 *Rocky Mountain News* interview, "When I got on the force there were eight or nine men from Ireland ahead of me. Things have changed. Today it's harder to find an Irishman [police officer] who was born in Ireland than a doctor that makes house calls." (Karyl Klein family photograph.)

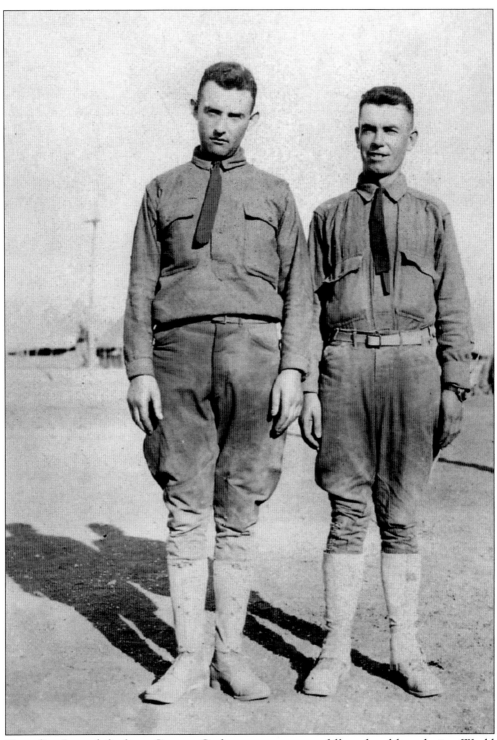

Cornelius Lucy, left, from County Cork, poses next to a fellow doughboy during World War I. Lucy was part of the long-standing Irish tradition of military service. (Karyl Klein family photograph collection.)

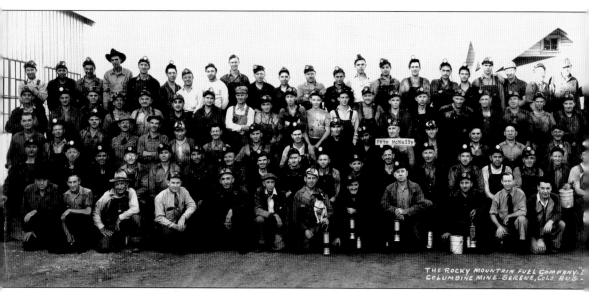

The Irish miner tradition continued long into the 20th century. This photograph captures the day shift at the Columbine Mine in Serene, Colorado. Irish American Pete McNally sits in the third row, sixth man from the right. McNally was often heard reciting the following poem: "By Mc and O, you always know, a true Irishman they say, if both lack the O and Mc, No Irishman are they." (Jim McNally family photograph.)

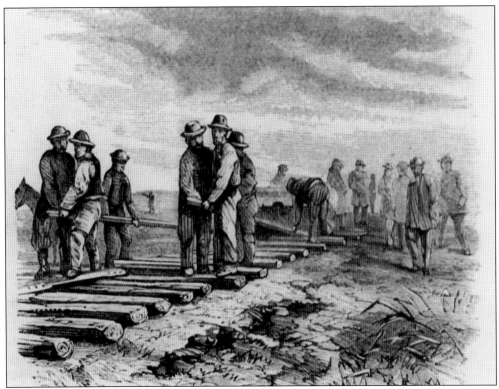

This drawing of Irish railroad workers, called "Gandy Dancers" because they used tools made by the Gandy Manufacturing Company of Chicago, appeared in *Harper's Magazine* in 1867. These laborers working in isolated territories faced high accident and death rates. (Thomas J. Noel collection.)

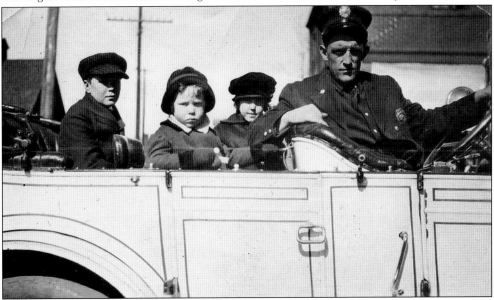

Long-serving Denver fire chief Jack Healy poses with his children John F., Catharine, and Thomas in a fire vehicle. Healy was fire chief of Denver from 1912 until his death in 1945. When Healy's wife passed away, he moved into a fire station. (Joanne Sessons family photograph collection.)

Martin J. Casey Sr., a native of County Tipperary, served as an officer and later captain in the Denver police force from 1874 to 1909. He owned a farm in Elizabeth, Colorado, where he grew a one-pound potato that he named the "Casey Potato." (Mary Ann Casey family photograph collection.)

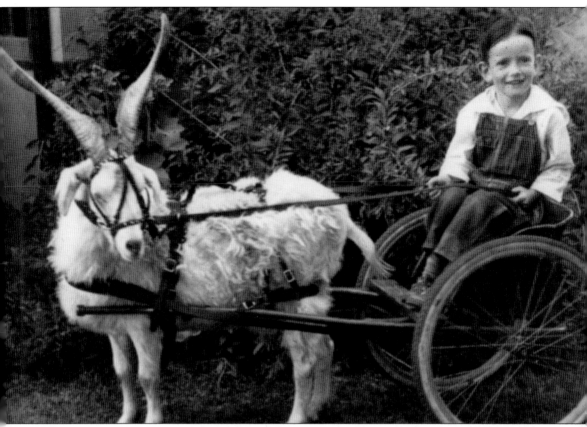

Some enterprising Denver photographers went door-to-door with a variety of animals to pose for pictures with families and kids. Some had ponies, others had small elk, and in this case, one had a billy goat. James Flaherty, the son of Mike and Nora Flaherty, pulls this horned beast to a "whoa" to the delight of River Drive neighbors in North Denver. (Dennis Gallagher collection.)

The majority of Irish miners came to Colorado from other mining areas in North America and the British Isles. Most of the Irish-born miners were from County Cork. Hundreds were from the Pennsylvania anthracite coal region of eastern Pennsylvania. Others came from the Adirondack lead mining region in Upstate New York, the copper mining region of Michigan's Upper Peninsula, the coal mines areas of Cape Breton in northern Nova Scotia, and the Cleator Moor mining district in northern England. (Colorado Mountain History Collection, Lake County Public Library.)

Two

KEEPING THE FAITH
THE IRISH CATHOLIC CHURCH

Fr. Joseph P. Machebeuf founded the Catholic Church in Colorado, starting out with Our Lady of Guadalupe Church (1858) in Conejos in the San Luis Valley and St. Mary's (1860) in Denver. Father Machebeuf, who became Bishop Machebeuf in 1868, began recruiting Irish priests and nuns.

Wherever the Irish settled in large numbers, they built Catholic churches—often naming them for St. Patrick, or at least installing a window or statue honoring Ireland's patron saint. Parishes named for St. Patrick popped up in Alma, Holyoke, Minturn, North Denver, Ouray, Silver Plume, Silverton, and Telluride. Although the first Irish archbishop, James V. Casey, did not arrive until 1967, many Irish clerics and nuns shaped Colorado Catholicism. William J. Howlett, the 10th of 12 children, became the first historian of the church in Colorado. He wrote a flattering portrait of Bishop Machebeuf, even though he had denied Howlett a suggested promotion to coadjutor bishop and assignment as rector of the cathedral parish. Machebeuf confidentially dismissed these ideas, writing that Howlett "had taken the uncouth manners and language of the miners." Howlett was neither the first nor the last Irish person to be downgraded for his lower-class accent and manners.

Joanna Walsh and her band of Sisters of Loretto founded Colorado's first private school, St. Mary's Academy in Denver, which flourishes to this day. Hibernian Catholic nuns also helped found the state's first hospitals, many of which still thrive.

The Sisters of Charity of Leavenworth opened St. Joseph Hospital in Denver in 1873. Sisters Mary Bridget Pendergast, Mary Crenscentia Fischer, and Francis Xavier Davy raised the needed funds, hired the carpenters and craftsmen, and supervised the construction of the first St. Vincent's Hospital in Leadville in 1879. As the hospital filled rapidly, the nuns raised another $4,000 more to add the "calico wall wards" where calico partitions made for increased privacy. Lake County paid the Sisters $1 per day for each indigent person at the hospital.

Catholic nuns, including many Irish women, not only ran hospitals, but also schools, orphanages, and refuges for the poor, the homeless, wayward girls, and troubled boys. Homesick Irish immigrants took great comfort in parishes and other institutions staffed by priests and nuns who shared the same Emerald Isle roots.

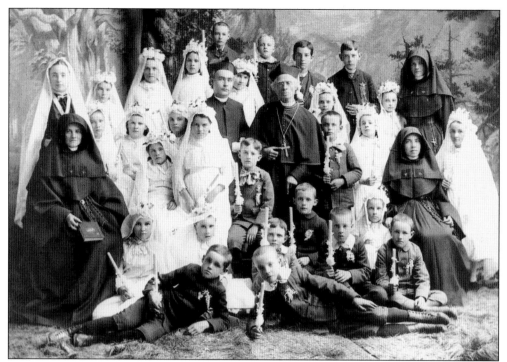

St. Mary's Academy, Colorado's first private school, was founded by Irish Sisters of Loretto Joanna Walsh, Ann Joseph Mattingly, and Agatha Wall as well as Sisters Beatrice Meas, Ignatia Mora, and Luisa Romero. In this c. 1885 photograph by Alfred Evans Rinehart, the Sisters and Bishop Joseph P. Machebeuf pose proudly with a Confirmation class. Originally in downtown Denver, St. Mary's has since moved to the Denver suburb of Cherry Hills. (Denver Public Library.)

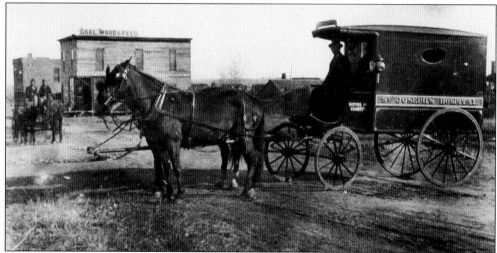

Irish Sisters of Charity of Leavenworth, including Theodora McDonald and Veronica O'Hare, helped found St. Joseph Hospital in 1874 on Denver's Market Street. When told that Market Street was Denver's notorious red-light district and a questionable location, the nuns replied, "We will take the question out of the neighborhood." St. Joseph relocated to their current home at East Eighteenth Avenue and Franklin Street. The shameless Sisters of Perpetual Indulgence remained on Market Street. (St. Joseph Hospital.)

In every town where they were numerous, the Irish strove to name the Catholic Church for Ireland's patron saint. This 1993 photograph by Thomas J. Noel shows St. Patrick's Church in Silverton, high in the San Juan Mountains of southwestern Colorado. The circuit-riding pastor Cornelius O'Rourke drowned while riding to the outlying missions in Eureka, Howardsville, Marshall Basin, Red Mountain, and Telluride to say Sunday Masses. (Photograph by Thomas J. Noel.)

Annunciation Catholic Church and School became the heart of Leadville's east-side Irish community. Rev. Henry Robinson, one of the most effective and popular pioneer priests, founded the parish in 1879. Many great Irish Catholic fortunes came out of Leadville's fabulously rich silver mines, including those of Molly and J.J. Brown. Annunciation's silvery steeple, pictured here in 2010, remains the tallest landmark in Leadville. Father Robinson later started Annunciation Parish in Denver, where he reached out to the Protestant community. (Photograph by Thomas J. Noel.)

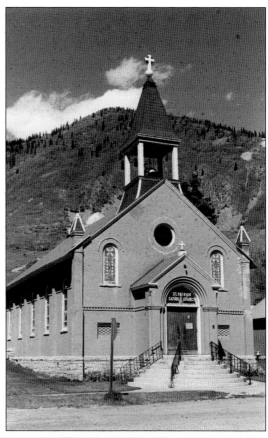

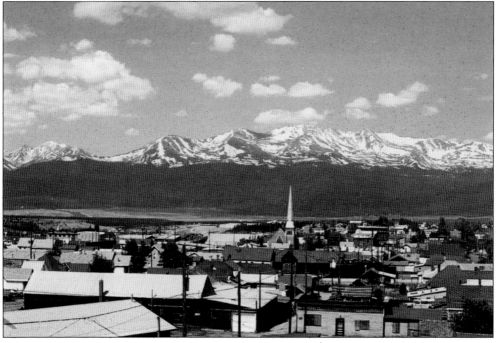

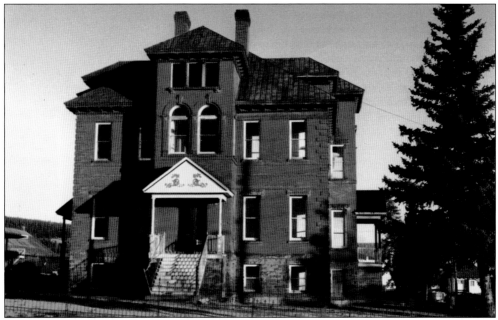

This St. Vincent's Hospital was built in 1900 in Leadville. The predominantly Irish Sisters of Charity of Leavenworth founded St. Vincent's in heavily Irish Leadville in 1879. The sisters begged in pairs, asking miners to pay $1 a month to St. Vincent's. In exchange, miners received free health care—not only for their bodies but also for their souls. As one of the nuns described their mission, "We never inquire about a patient's religion. So long as there is room we take all who come, whatever may be their color, creed, or nationality." When lot jumpers tried to seize the hospital property, they were met by the Wolfe Tone Guards, an Irish militia. One of the lot jumpers was shot in the leg and then treated at the hospital by the nuns, who lived up to their creed of never turning anyone away. (Thomas J. Noel collection.)

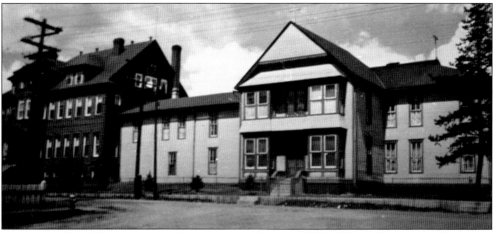

The original St. Vincent's hospital, at right, was built in 1879. When the number of patients grew, a larger brick hospital, at left, was built in 1900 to replace it. This brick structure still stands today, while the original structure was torn down shortly after the brick one was built. (James P. Walsh collection.)

The Sisters of Mercy, founded in Dublin in 1831 by Irish heiress Catherine McCauley, came to Denver to build St. Catherine's Home for Working Girls. The Sisters of Mercy also built and ran Mercy Hospitals in Denver and Durango and schools in various Colorado communities. In this 1994 photograph, the Sisters of Mercy go to bat to raise funds for their Denver hospital. (Photograph by James Baca, *Denver Catholic Register*.)

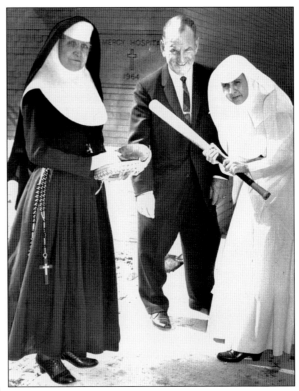

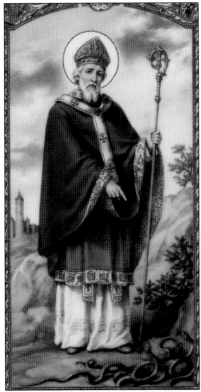

In parishes where they were numerous, the Irish insisted on a statue or a stained-glass window of St. Patrick (c. 385–461). A British Christian and citizen of Rome, he was captured as a lad by the Irish, who enslaved him for six years as a herdsman. After escaping, he later returned to convert the Irish to Catholicism and became the patron saint of the Emerald Isle. (Thomas J. Noel collection.)

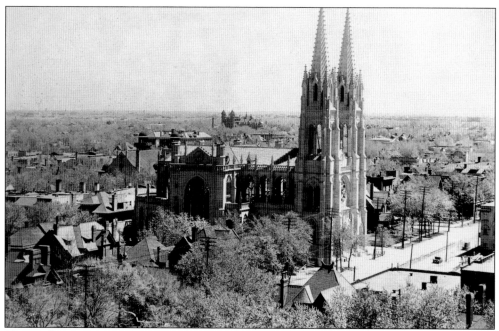

Flour-milling magnate John K. Mullen, Margaret "Molly" Brown, John F. Campion, and bankers John Mitchell and Dennis Sheedy, as well as other Irish givers, pitched in to fund construction of Immaculate Conception Cathedral on Denver's Capitol Hill. Note the twin towers of St. Joseph Hospital in the background of this 1912 image. (Photograph by Louis McClure, Denver Public Library.)

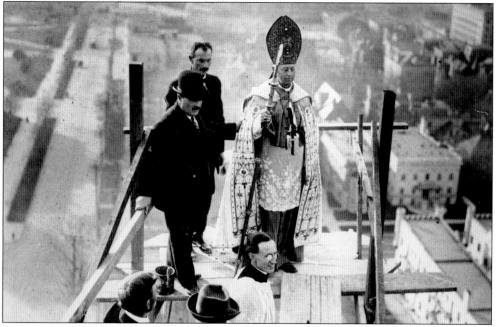

High above the 1912 Dedication Day crowd of 20,000 Card. John Farley of New York and Msgr. Hugh L. McMenamin of the cathedral gave a special blessing to the spires of Immaculate Conception Cathedral. (Denver Public Library.)

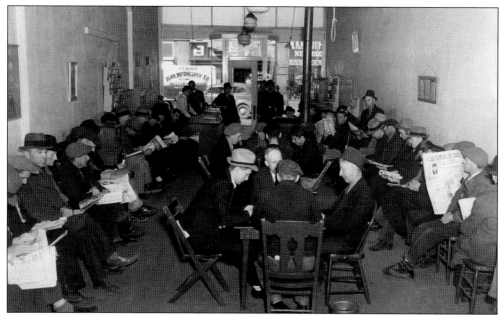

The founding father of Colorado Catholic Charities was Msgr. John R. Mulroy. An Irishman, he came West a thin, weak health-seeker but became a robust giant who speared the church's social services. Among the many church programs he expanded was the oldest, the St. Vincent de Paul Society, which ran this Workingman's Club at 1824 Larimer Street. The hungry, unemployed, and homeless found food, shelter, and a warm, welcoming place to read or play checkers here. (Photograph by Paul E. Norine.)

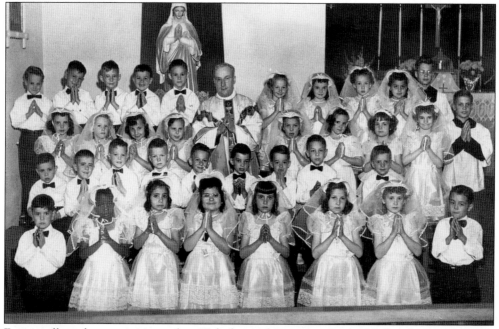

Even small rural communities such as Holyoke on the eastern plains of Colorado attracted Irish immigrants. They helped found that town's St. Patrick's Church, which boasted this 1953 First Communion class. (Archdiocese of Denver Archives.)

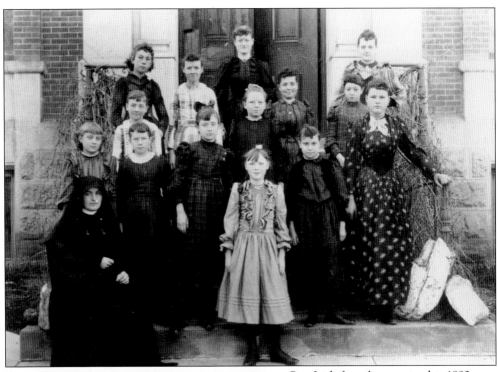

Can Irish faces be seen in this 1892 photograph? Sister Mary Linus poses with her St. Mary's Academy fifth-grade students. From left to right are (first row) Kate Mullen; (second row) unidentified, Mary Griffith, Anne Connors, Kate Able, and unidentified; (third row) Bessie Kennedy, Agnes Eagan, and Pearl Ellis; (fourth row) Lillian Fielding, Cora Kennedy, and three unidentified. Kate Schaffer guards the door. (Photograph by Walter H. Foreman; Denver Public Library.)

Many Irish attended Sacred Heart Church after it opened in 1878 at Twenty-eighth and Larimer Streets. This restored landmark is Denver's oldest church still in use as a church—in the original building on the original site. (Thomas J. Noel collection.)

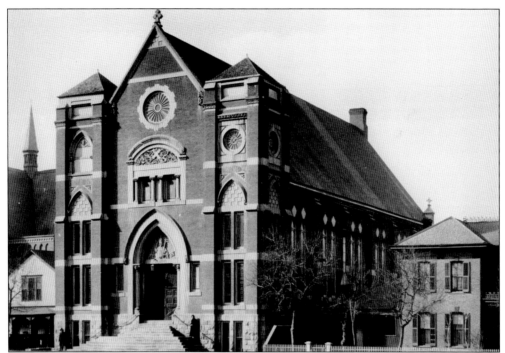

Pictured around 1900, St. Leo's Church stood at Tenth Street and West Colfax Avenue from 1889 to 1965 and attracted many Irish parishioners. Pastor William A. O'Ryan from County Tipperary edited the *Colorado Catholic* and the *Celtic Cross*. Father O'Ryan also cofounded the Community Chest, now the United Way, with Rabbi William S. Friedman of Temple Emanuel, Dean Martyn Hart of St. John's Episcopal Cathedral, Jewish philanthropist Francis Wisebart Jacobs, and others. Father O'Ryan presided over St. Leo's for 48 years. An intellectual bibliophile, he spearheaded the ecumenical movement. (Photograph by Louis McClure; Denver Public Library.)

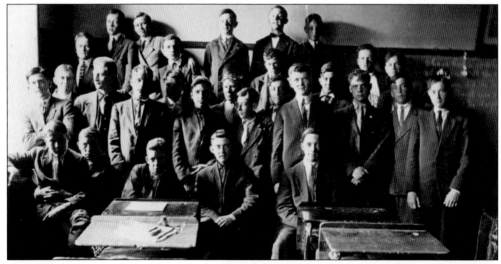

Cornelius Lucy is in the center of this c. 1910 photograph with his class at Regis High School. The school continues to practice the Jesuit philosophy of education today in its new location in Aurora, Colorado, helping to produce men and women in service to others. (Karyl Klein family photograph collection.)

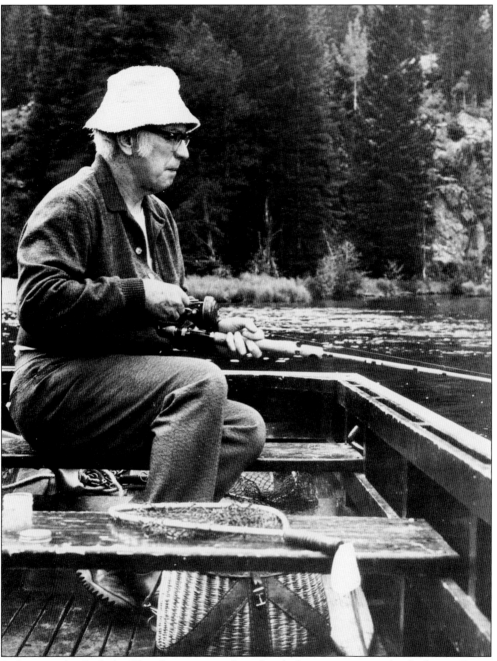

Irish ties to the Catholic Church were strengthened with the appointment of an Irishman, James Casey, as the first Irish archbishop of Denver, 1967–1986. He greatly expanded the church's social services for the homeless, the hungry, and the down and out, only once in a long while taking time out for fishing. (James Baca.)

Three

HIBERNIANS AND FENIANS
IRISH FESTIVALS AND
NATIONALIST ORGANIZATIONS

The Irish in Colorado created dozens of organizations, usually fraternal, nationalist, or religious in nature. The largest and most prominent of these is the Ancient Order of Hibernians (AOH), a fraternal organization that originated in America in New York City in 1836 to promote Irish heritage, interests, and welfare.

The first AOH chapter in Colorado was organized in 1878 in Central City/Blackhawk/Nevadaville. A Leadville chapter opened in 1879 grew to over 300 members by 1884.

By 1900, Colorado had 12 active branches of the AOH. Denver's chapter, chartered in 1889, defended the church against real and perceived attacks from anti-Catholic elements. The AOH also challenged offensive depictions of the Irish as apes, drunks, and other derogatory images. Its members sometimes disrupted plays featuring "vulgar" stage Irishmen. One play with a particularly offensive scene at a Denver opera house in 1877 had to be stopped when Irishmen showered the stage with rotten eggs.

Denver hosted the national AOH convention in 1902. By then, the Queen City boasted 1,000 AOH members and five chapters.

Another important Catholic fraternal organization, the Knights of Columbus, opened its first Denver council in 1902. Other heavily Irish fraternal groups in Colorado included the Knights of Robert Emmet, the United Irish Societies, and the National Gaelic League.

Irish women created their own societies, such as the Ladies Land League, the Daughters of Erin, and a Ladies Auxiliary of the AOH.

Colorado's Irish also created their own militias, both for protection against anti-Irish elements and as a means of earning respectability. Leadville's Wolfe Tone Guard was named for Theobald Wolfe Tone, a Dublin-born Protestant who led the United Irishmen in the Irish Rebellion of 1798.

The Wolfe Tone Guard gained fame when Gov. Frederick Pitkin tried to disband them after they refused to participate in suppressing the Leadville miners' strike of 1880.

Later, this Leadville group was renamed the Rocky Mountain Rifles. Denver's first Irish militia, formed in the 1870s, was the Mulligan Guard. All of these organizations fostered Irish solidarity and pride in a sometimes ridiculed and persecuted group.

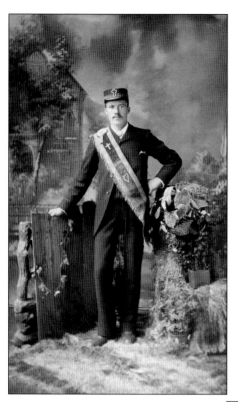

A proud member of Ancient Order of Hibernians in Georgetown, Colorado, poses around 1900 with his sash bearing an Irish harp and a cross. By 1900, a total of 12 AOH chapters existed across the state. These fraternal groups offered Irish Catholics much needed social space to highlight their virtues and oppose the anti-Catholic efforts of groups such as the American Protective Association, the Citizens' Alliance, and the Ku Klux Klan. (Denver Public Library.)

Hibernians were standard targets for vaudevillian humor portraying them as subhuman. In theaters like Denver's Tabor Grand Opera House, vigilant AOH members protested performances making fun of the Irish. A Leadville newspaper described such an event in 1880: "Ten or fifteen Irishmen arose in the audience and began throwing eggs, stones and other missiles at the people on stage, shouting at the same time, 'Get off that stage, you dumb sons of bitches.' The missiles became so numerous that for a time the play had to stop and the actors retire from the stage." (Denver Public Library.)

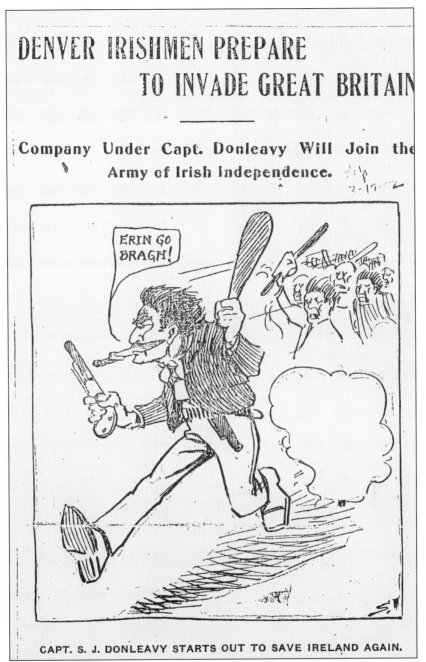

DENVER IRISHMEN PREPARE
TO INVADE GREAT BRITAIN

Company Under Capt. Donleavy Will Join the
Army of Irish Independence.

CAPT. S. J. DONLEAVY STARTS OUT TO SAVE IRELAND AGAIN.

This cartoon, published in the March 19, 1902, edition of the *Denver Republican*, mocks "Captain" S. J. Donleavy, secretary of the Denver Fire and Police Board, for his efforts to lead a company of Irish "Fenians" to liberate Ireland from English rule. Donleavy also tried to lead a group of Irishmen to South Africa to fight the British in support of the Boers. Denver's Fenian brotherhood started in Denver on October 5, 1866. Their constitution and bylaws stated, "The Fenian Brotherhood is an independent and distinct organization, and is composed in the first place of citizens of the United States of America of Irish birth and lineage, and the second place of Irishmen and friends of Ireland living on the American continent." (Phil Goodstein collection.)

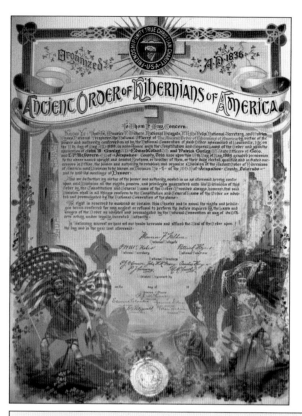

Pictured is the original charter for the Denver branch of the Ancient Order of Hibernians. This unit lapsed in the mid-20th century but was restarted in 1977 by Ed Kennedy, Jack Wemyss, and Jim Sweeney. The organization again lost steam until its 1985 revival as the Michael Collins Chapter. (Aidan McGuire, AOH Collection.)

The *Rocky Mountain Celt* was an Irish weekly paper in Denver during the 1880s. This edition trumpeted the political independence of Denver's Irish community, proclaiming that "it is a blessing for the Irish people of this city and state that we have no political bosses or leaders. We are proud to say that the Irish inhabitants of Colorado are intelligent and strongly opposed to bossism." (James Walsh collection.)

THE ROCKY MOUNTAIN CELT.

VOLUME 5. DENVER, COLORADO, SATURDAY, JULY 19, 1884. NUMBER 2.

STEPHENS AND HIS CRITICS.

REPLY TO IRISH-AMERICAN JOURNALISTS.

A REVIEW OF IRELAND'S HISTORY.

PHYSICAL FORCE AS AGAINST MORAL SUASION.

THE RESTORATION OF AN IRISH LEGISLATURE.

THE PROPAGANDA OF MR. PARNELL.

PARIS, June 18.—Recent articles of mine, and more particularly of that which appears in the columns of the Contemporary Review, have been subjected to extraordinary criticism on the part of the Irish-American newspapers. These periodicals, more or less devoted to the interests of the National League, seem to be unable to tolerate any free and candid expression of opinion whatever on the defects and drawbacks of the movement which aims, through constitutional means at the regeneration of Ireland. It looks as if they were assured that the physical power party should bow down before the agitators whose principles must be considered the only true one in the arena of Irish politics, and whose must be-blindly followed by every man who has the welfare of his Irish motherhood at heart. I am inclined to the belief, which I may say from the information I have received, is a well founded one, that the watchword, "no toleration," has

PEOPLE WILL TALK.

You may go through the world, but 'twill be very slow,
If you listen to all that is said as you go;
You'll be worried, and fretted, and kept in a stew—
For meddlesome tongues must have something to do,
 And people will talk.

If quiet and modest, you'll have it presumed
That your humble position is only assumed—
You're a wolf in sheep's clothing or else you're a fool;
But don't get excited—keep perfectly cool—
 For people will talk.

And then if you show the least boldness of heart,
Or a slight inclination to take your own part,
They will call you an upstart, conceited and vain,
But keep straight ahead—don't stop to explain—
 For people will talk.

If threadbare your dress, or old-fashioned your hat,
Some one will surely take notice of that,
And hint rather strong that you can't pay your way;
But don't get excited, whatever they say—
 For people will talk.

If your dress is fine, don't think to escape,
For they criticise then in a different shape;
You're ahead of your means, or you tailor's unpaid,
But mind your own business—there's naught to be made—
 For people will talk.

Now, the best way to do is to do as you please,
For your mind, if you have one, will then be at ease.
Of course you will meet with all sorts of abuse,
But don't think to stop them—it ain't any use—
 For people will talk.

CHOLERA IN EUROPE.

All Europe is becoming alarmed at the appearance of cholera in

GROVER CLEVELAND.

Democratic Nominee For President.

An EVENT of the Irish People.

and breadth of the land. This feeling, however, had its origin, not so much in the failure of the J. R. B. and Fenian Brotherhoods as in the policy suddenly adopted in regard to Ireland by one of England's greatest statesmen, Mr. Gladstone, consequent on the Clerkenwell explosion, which seemed to have had the effect of opening that gentleman's eyes to the real wrongs under which the so-called sister island was groaning. Much as I have censured the British premier's conduct of late years, I must, nevertheless, do him the justice of expressing my belief, that he tried just then, as an honest and sincere Englishman, to remedy Ireland's ills. When he challenged John Martin on the floor of the House of Commons to dispute with him the good will and affection of the Irish people, Mr. Gladstone entertained high hopes of putting down disaffection by removing its causes which produced it. By abolishing Protestant ascendancy he

THOMAS A. HENDRICKS.

Democratic Nominee for Vice-President.

A FRIEND of the Irish People.

The Pope's Dog.

Pope Pius II. had a little puppy dog of eleven months, which he called Musetta. "She was white but not very pretty, yet clever and affectionate, with winning ways. One day as the Pope was sitting in the Vatican garden transacting business, Musetta in her rambles clambered up the sides of a water cistern and tumbled in. The Pope's ear caught the piteous tones of her bark and he sent his attendants to look after her. They arrived just in time to save her life and she came back to the Pope with demands for his sympathy. Next day, in the same garden, a big monkey broke loose and almost worried Musetta to death. The Pope prophesied that his favorite would not destined to enjoy a long life. His prophecy was soon fulfilled. Ten days afterwards the luckless Musetta was looking out of an open window when a wind suddenly arose and blew her over. She fell from a considerable height

IN SACRED PALESTINE.

THE HOLY LAND AS DESCRIBED BY A PRIEST.

SCENES MADE FAMOUS BY THE SCRIPTURES.

INTERESTING COMMUNICATION FROM JERUSALEM.

REV. FATHER JAMES J. KEENAN'S LETTER.

BETHANY-GETHSEMINI, CALVARY AND MOUNT OLIVET.

The following very interesting letter which was received by Mrs. Senator Tabor during the week, was kindly handed to a representative of THE CELT for publication. It beautifully describes some scenes and incidents of Christ's life.

JERUSALEM, May 30, 1884.

Mrs. H. A. W. Tabor.

DEAR FRIEND—I thought at different times of writing to you a few lines as I promised. I reached this city, Jerusalem, about five days ago. Here is concentrated, I may say, everything that is holy. Here are all the scenes and places made holy by the life sufferings and death of our Blessed Lord and His Holy Mother. Since I came here I offered Mass on Mount Calvary, where Our Lord was crucified for the grace of a happy death for your family and myself. To-morrow I shall say Mass in the Holy Sepulcher, where Our Lord was crucified or on Mount Calvary on you.

I had a long and tedious journey of more than 7,000 miles to reach this city, and it was anything but pleas-

The London Times says that the platforms of both political parties are unworthy of respect. It is too bad that the editor of the Times was not consulted about the matter. If the Times will only urge upon the British government the necessity of preventing its subjects from becoming maniacs from want of food and clothing, it would confer a great favor upon the famine-stricken and fearfully persecuted inhabitants of the British Islands. Once engaged in a work of this kind the Times would be read with interest in this country. But while outrages of all description are committed in the name of law in Ireland, the Times invariably sides with the oppressor. A paper without character has never any influence, and it is a good many years since the Thunderer lost its character.

American travelers cannot be too careful of what they carry in their trunks when they reach London. Frank D. Millet, a well-known New York artist, on arriving in London by the steamship Erin, on her last voyage, was kept in custody during an entire day, while the authorities investigated some maple sugar that was found among his effects. They felt sure it was dynamite.

The crops are looking remarkably well in every State and Territory of the Union. Encouraging reports are being daily received in this city from various sections of Colorado. The husbandman will undoubtedly feel happy, return thanks to the Almighty and rejoice in the autumn of the year.

An exchange says that the Democratic party seems to think that it has a mortgage upon Irish-American voters. Time was, we admit, when they invariably voted the Democratic ticket, but the time has

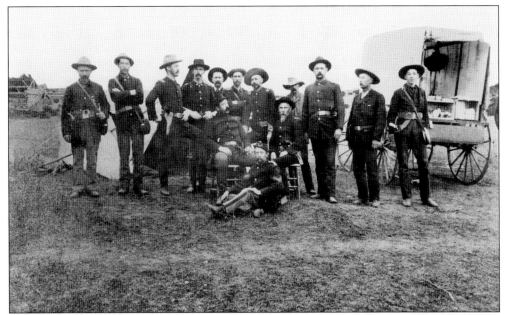

Members of the Rocky Mountain Rifles, an Irish American militia, formed part of the Colorado National Guard in the 1880s and 1890s. The *Leadville Evening Chronicle* wrote, "Every man in the Rocky Mountain Rifles is Irish or Irish descent." The Rifles were called out to suppress uprisings by the Utes in 1887 and the Navajo in 1893. (Denver Public Library.)

The Romley Boardinghouse in Cripple Creek housed and fed many Irish immigrants, extending a special welcome to miners' wives and children. (Lisa Rogers family collection.)

This now-demolished Fraternal Building at the corner of Fifteenth and Glenarm Streets originally housed the Knights of Columbus. The Knights were founded in 1882 by Fr. Michael McGivney in New Haven, Connecticut, to aid members and their families, especially the sick, disabled, and needy. Social and intellectual fellowship is promoted among members and their families through educational, charitable, religious, social welfare, war relief, and public relief works. The Colorado Knights of Columbus originated in Denver in 1902 and today boasts 39 councils who proudly hosted the Knights 2011 National Convention in the Mile High City. (Thomas J. Noel collection.)

ROYAL WELCOME
FOR HIBERNIANS

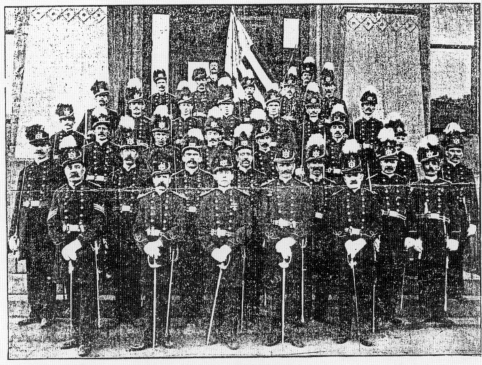

DENVER HIBERNIAN KNIGHTS.

The Hibernians of Denver and Colorado will have the honor of entertaining the national convention of the Ancient Order of Hibernians next year. Preparations to this end are under way and when the thousands of delegates and visitors reach the Queen City of the Plains they will find a Cead Mille Failthe

"Cead Mille Failthe" Adorns the Banner Under Which Denver Will, Greet the National Convention.

This 1901 article in the *Denver Times* trumpeted preparations to welcome the national AOH convention in the summer of 1902. The article declared, "When the thousands of delegates and visitors reach the Queen City of the Plains they will find a Cead Mille Failte awaiting them and Irish hospitality will be the order of the period." The Denver Hibernian Knights were on guard after a St. Patrick's Day incident in 1900 when a near riot erupted in downtown Denver after a 20-foot orange flag was raised over city hall. After a great crowd gathered to protest the banner, the *Denver Times* reported, "A fireman hauled down the flag and a war dance was executed around its remains, as turkeys dance about a scarlet rag. Then the faithful ran out a green flag over the mayor's office." (James Walsh collection.)

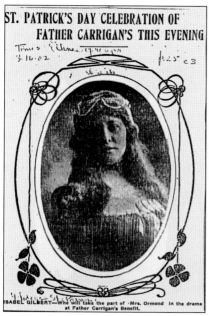

ST. PATRICK'S DAY CELEBRATION OF
FATHER CARRIGAN'S THIS EVENING

ISABEL GILBERT—Who will take the part of 'Mrs. Ormond' in the drama at Father Carrigan's Benefit.

St. Patrick's Parish pastor Fr. Joseph P. Carrigan was known for St. Patrick's Day celebrations and benefits. This 1902 St. Patrick's Day article in the *Denver Times* highlights a local actress who performed in one of his benefit dramas. The popular Carrigan often clashed with Bishop Nicholas Matz, who ultimately removed him from St. Patrick's, exiling him to a Glenwood Springs parish. The bishop objected to Father Carrigan's ecumenical outreach to non-Catholics and his argument that poor Catholics should be given respectable burial at Mount Olivet Cemetery. Carrigan became legendary in North Denver for persuading the city to turn the Twentieth Street viaduct north to land at Thirty-third Avenue and Osage Street, just in front of St. Patrick's Church. (James Walsh collection.)

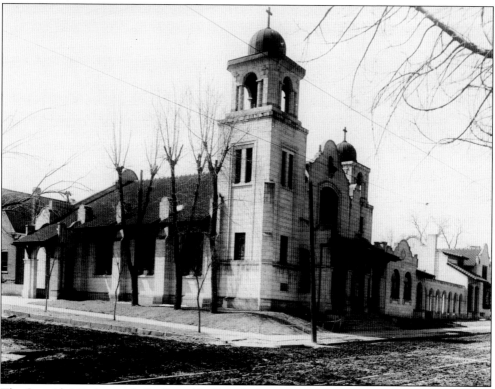

The Spanish Mission–style St. Patrick's Church in northwest Denver at 3401 Pecos Street was built in 1911 by Fr. Joseph P. Carrigan. Father Carrigan organized St. Patrick's Day fundraiser galas that evolved into what may have been Denver's first official St. Patrick's parade in 1906. This landmarked church, pictured around 1912, and the earlier St. Patrick's at 3233 Osage Street survive. (Photograph by Louis McClure; Denver Public Library.)

Four

WET AND DRY GOODS
HIBERNIAN ENTREPRENEURS

Despite stereotyping and discrimination, the Irish made it in America because of their hard work. They typically started out in menial, backbreaking labor but often worked their way to the top. The first generation built railroads, toiled in mines, fought in the Army, dug ditches, and constructed roads and buildings.

Irish laborers were welcome in rapidly industrializing, labor-short Denver, as a snide letter reprinted in the *Rocky Mountain News* suggested: "Dear Patrick / Come! A dollar a day for ditching, no hanging for stealing, Irish petaties a dollar a bushel, and Whiskey the same!"

Many came as "terriers," as the Irish railroad workers called themselves. The majority of Irish, however, came to Colorado to work in the mines. They gravitated to mining towns such as Leadville. Celtic pubs soon sprouted up in many mining towns like shamrocks in spring. Irish working-class neighborhoods in north and central Denver also found solace in open saloon doors, out of which drifted such tunes as "Danny Boy," "My Wild Irish Rose," "You'll Never Find a Coward where Shamrocks Grow," "Wearin' of the Green," and "Where the River Shannon Flows."

The Irish-born represented less than three percent of the Mile High City's population in 1900, yet they operated 10 percent of the city's taverns. These saloons helped to explain why Irishmen were able, in a predominantly non-Irish city, to elect their countrymen to local, state, and national office. Political power revolved around an alliance of saloonkeepers, politicians, and policemen, three occupational groups that attracted large numbers of gregarious, politically active Hibernians.

John K. Mullen, Denver's best-known Irishman, hired many of his countrymen at his huge Hungarian Flour Mill, which evolved into a national giant, the Colorado Milling and Elevator Company. All too well aware of the alcoholism that haunted his people, Mullen founded and financed the St. Joseph Catholic Total Abstinence Society.

Hard work, as well as hard play, characterized the Irish, including the Irish servant and working girls who asked only Sunday mornings off so they could go to Mass. The men started out in the lowest paying, most difficult and dangerous work, but they often persevered and climbed upward.

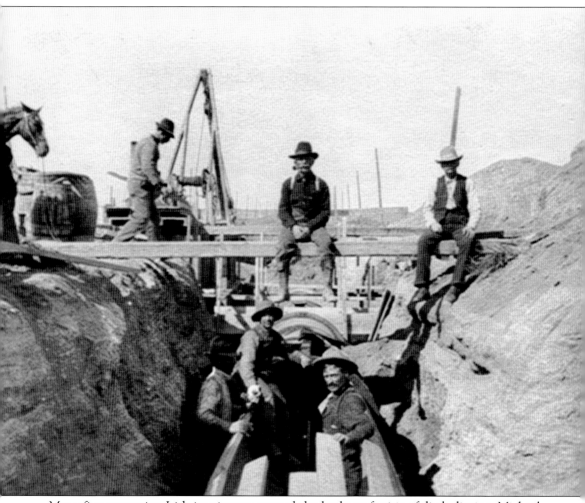

Many first-generation Irish immigrants entered the lowly profession of ditch digging. Michael Lawrence Flaherty, seated lower center, toiled as a ditch digger for Denver Union Water Company and installed many of the oak panels on the city's original wooden pipe water system. Flaherty later moved up to bartending at Madden's Wet Goods, a union bar at 1140 Larimer Street. Moving on to an even better paying job, he went to work at J.K. Mullen's Hungarian Mill. (Dennis Gallagher collection.)

William Gallagher, a County Sligo–born fireman on the Moffat Railroad, once passed out as train smoke overwhelmed him in the Corona Pass snow shed atop the Continental Divide. Fellow workers carried him to the telegraph operator's cabin. As he lay groaning on the floor, the telegraph operator's wife arrived with ammonia. With trembling hands, she attempted to give him a whiff of the ammonia but got some of it down his nose. Gallagher came to life like three madmen. The woman fled, as members of the train crew were unable to hold Gallagher to the floor. He smashed furniture, tore the phones from the walls, and wrecked the office and instruments. Gallagher recovered to become a locomotive engineer. He worked the Moffat Road, which crossed the Rockies through such spectacular scenery as Yankee Doodle Lake. (Both, Dennis Gallagher collection.)

Thomas Francis Walsh was born into a poor family in Lisronagh, County Tipperary, Ireland, and died a multimillionaire in his mansion in Washington, DC (now the Indonesian Embassy). His Camp Bird Mine, high in Colorado's San Juan Mountains, proved to be one of Colorado's richest and longest producing treasure chests, filled with gold and silver. With its proceeds, he bought the Hope Diamond for his daughter Evalyn Walsh McLean. (Denver Public Library.)

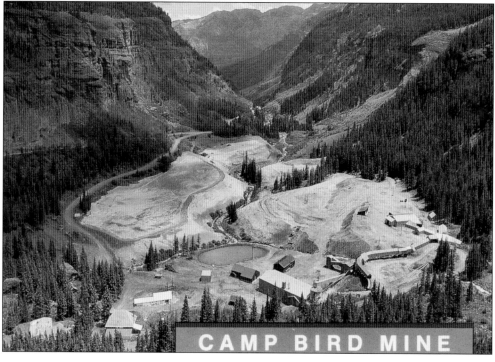

CAMP BIRD MINE

"My story," Dennis Sheedy wrote in his autobiography, "is of a poor boy who started out alone in this world to carve out a fortune and did." Sheedy initially made a bundle in the cattle business, then spearheaded organization of the Denver Dry Goods and the Globe Smelting and Refining Company while serving as vice president of Colorado National Bank. His sister back in Ireland, a nun, kept reminding him of the biblical warning that it is harder for a camel to pass through the eye of a needle than it is for the rich to get into heaven and begged him to send more money back to the Old Country for charity. Perhaps to reassure his sister and other doubters, Sheedy had the angel above his Fairmount Cemetery memorial point heavenward. (Thomas J. Noel collection and Roger Whitacre.)

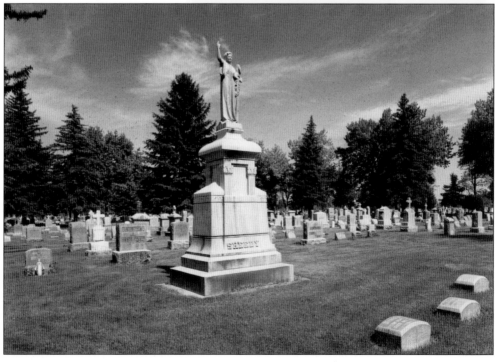

Bernard Duffy opened Duffy's Shamrock Tavern in 1950 at this 1645 Tremont Place location, and it soon became Denver's most celebrated Irish saloon. After outgrowing this site, Duffy's moved to 1635 Court Place. It was especially jammed on St. Patrick's Day. One reveler took off all his clothes in the rear bathroom and streaked for the front door. It took him 10 minutes to get through the crowd, who never even noticed his nakedness. After he finally got to the front door, police officers arrested him. (Thomas J. Noel collection.)

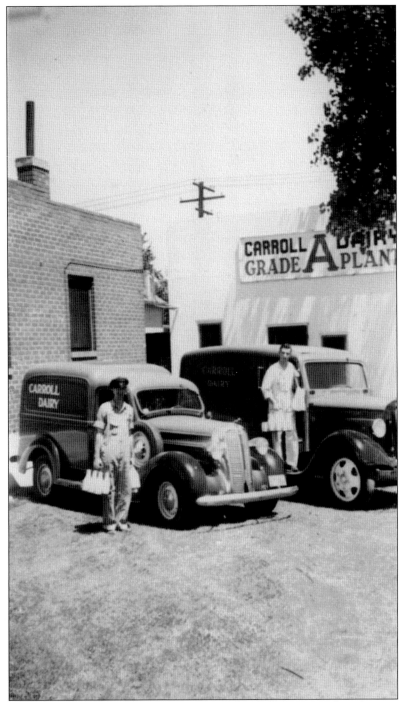

Two drivers for the Carroll Dairy are shown here. Owner Thomas Michael Carroll started the dairy in 1938. His wife, Alice Bridget McGuire, and their seven children all worked at this Alameda and Logan Street site. To make ends meet, the family sold Christmas trees at the dairy and the boys sold newspapers along Broadway. All seven children attended Regis, Mullen, St. Mary's Academy, or Marycrest. (Bridget Stoklosa family.)

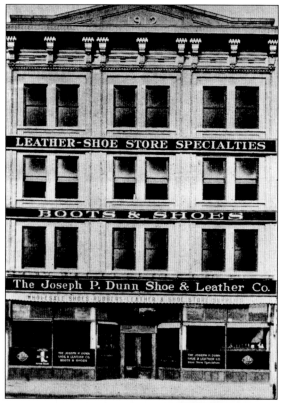

The Joseph P. Dunn Shoe & Leather Company typified many Hibernian small businesses. Dunn started out in a small shop at 1440 Market Street in 1888. With strong support from his family and fellow Irishmen, Dunn prospered, ultimately moving into this fine four-story building at 1825 Lawrence Street. (Jeannette Shea/Zook family.)

The Feely family of Irish immigrants took pride in operating one of Denver's water wagons, used to keep street dust down. From left to right are Michael John Feely, John Patrick Feely, Mary Gibbons Feely, Nell McHugh Feely (Michael's wife), John Patrick Feely (son of Michael), Ann Cavanaugh Feely (wife of Thomas Francis Feely), George Louis Feely (youngest of Michael's sons), and James Thomas Feely (son of Michael). (Rich Feely.)

John Kernan Mullen, a County Galway native, started out working as a volunteer at a Denver flour mill and volunteered to break winter ice in a flour mill water course. He quickly rose through the ranks to become the milling magnate of the Rockies and Colorado's best-known Irish philanthropist. (Denver Public Library.)

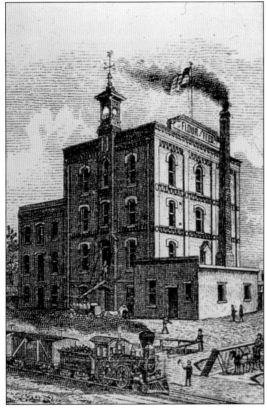

John Kernan Mullen built this Hungarian Flour Mill on Wazee Street in Denver. It evolved into the Colorado Milling and Elevator Company, a huge conglomerate controlling mills, grain elevators, and wheat fields from the West Coast to the Mississippi River. His fortune enabled him to found the Mullen Home for Boys (now Mullen High School), donate the land and funding for Denver's St. Cajetan's Church, and establish Mullen Scholarships. (Colorado Historical Society.)

49

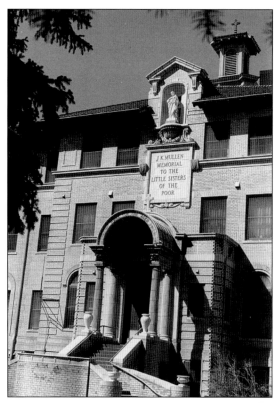

J.K. Mullen founded Denver's Mullen Home for the Aged, where the Little Sisters of the Poor care for the elderly 24 hours a day, seven days a week. Ever since its 1918 opening, the Mullen Home has been filled as the sisters provide superb, compassionate care and aspire only to be "the humble servants of the poor." As a mendicant order, the sisters even persuaded the Coors Brewing Company to provide liquid refreshment for their elderly residents. (Both, photographs by James Baca; *Denver Catholic Register.*)

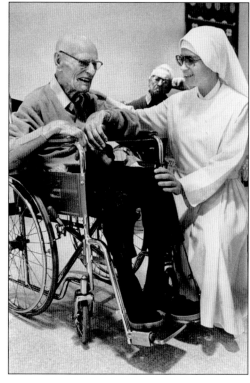

The majority of Irish immigrants found work in Colorado mines. Some did well. John F. Campion struck it rich in Leadville with his Little Jonny, which claimed to be the world's richest gold mine. Campion made a fortune and assembled the finest Colorado collection of gold and silver specimens, which he donated to the Denver Museum of Nature and Science as its core mineral collection. (Denver Public Library.)

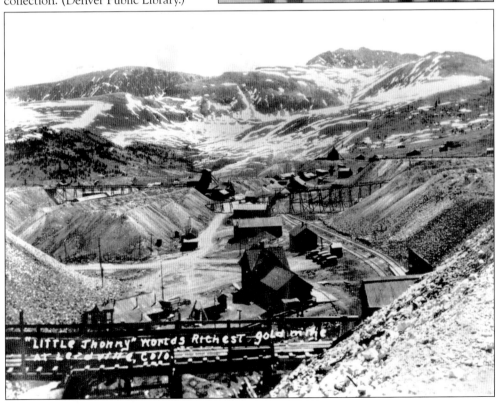

Most immigrants from the Emerald Isle had been farmers in the Old Country, and many tried farming in Colorado. One of the first, John Gully, became a pioneer settler in what is now Colorado's third largest city, Aurora. The Gully Homestead House, which dates back to the 1860s, and the Delaney Round Barn, built by a Gully son-in-law, have been restored as the centerpieces of Aurora's Delaney Farm Open Space Park. (Thomas J. Noel collection.)

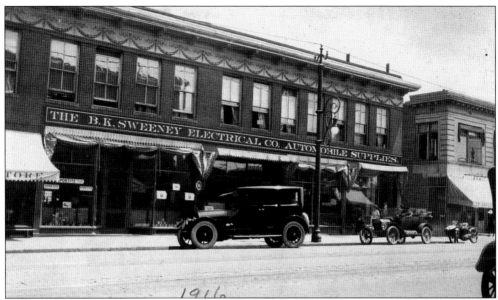

1916

Jumping aggressively into the 20th century, Bayard K. Sweeney started in 1901 what became one of Denver's leading electrical and automotive parts stores in this uptown operation at 221–231 Fifteenth Street. Like many third-generation Irishmen, he remained active in Catholic and Irish Clubs, including the Knights of Columbus and Big Brothers. (Barry Sweeney.)

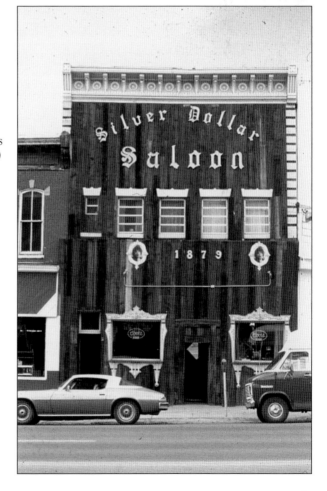

The Silver Dollar Saloon has lubricated Leadville since 1879. The McMahon family, owners since 1943, made it the town's Irish headquarters and the official last stop of the St. Patrick's Practice Day Parade held on or near every September 17. (Thomas J. Noel collection.)

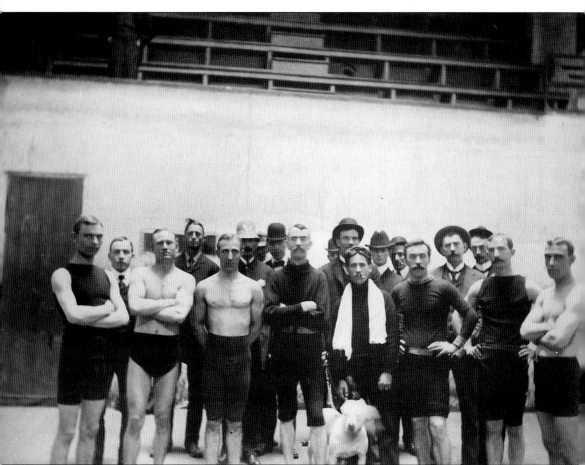

Dublin-born John Francis Fortune ran a men's outfitter business at 3795 Walnut Street. John played handball with many of his customers, as shown here. The business served the fashion-conscious men of Denver with custom-made suits of imported wools and simultaneously catered to the working-class railroad workers and families living in Cole and surrounding neighborhoods. Fortune, a boxer, cyclist, handball player, coach of local baseball teams, and a devout Catholic, actively ran the successful business with the help of his wife, Katherine; three sons, James, Thomas, and John; and daughter Kathleen. The family lived near and belonged to Annunciation Parish, where the children attended Annunciation grade school. The sons attended Regis High School and Regis College. Kathleen graduated from St. Mary's Academy. (Nita Kennedy family photograph collection.)

One of Colorado's favorite Irish success stories is that of Kevin McNicholas. Raised in a poor family, Kevin went to work as a lad peddling food at Denver's National Western Stock Show. He soon rose to the top by serving the best roast beef in town—with the hottest horseradish. After Kevin married Mary Eldredge, the couple founded K-M Concessions, which now serves not only the Stock Show but also 35 other locations, including the Denver Zoo, History Colorado, and zoos nationwide from Honolulu to Buffalo. This family business has become a national enterprise, and the McNicholas clan is quite philanthropic, raising and giving millions to many Irish and Catholic causes. (Mary McNicholas.)

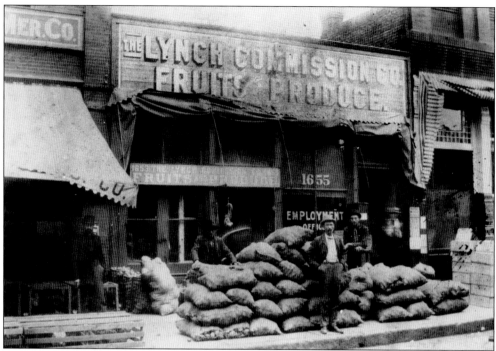

Patrick Lynch immigrated to the United States from County Galway with his parents when he was only seven years old. He made his way to Colorado and worked in produce in Denver and Pueblo, eventually starting the Lynch Commission Co. Fruits and Produce business in downtown Denver. His wife, Mary Lyons Lynch, and their six children helped run the family business. He is said to have frequently donated food to Mother Cabrini. (Loretta E. Davis family photograph collection.)

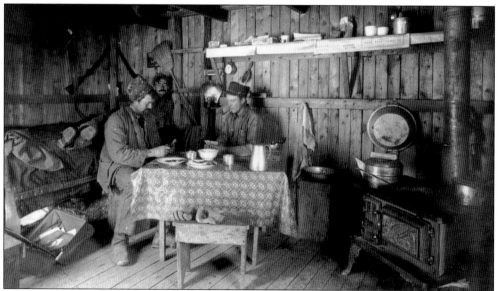

Miners first organized informally in scattered cabins in the pursuit of green collar solidarity. During the 1880s, workers began joining unions to fight for better pay, shorter hours, and better working conditions. (Courtesy of Denver Public Library.)

Five

GREEN COLLAR SOLIDARITY
IRISH LABOR LEADERS

The Irish in America have always taken important and courageous leadership roles in the struggle for workers' rights. Colorado's first major organized union, the Miners' Cooperative Union—an affiliate of the Knights of Labor—launched the first major strike in Colorado history in May 1880 in Leadville, when an estimated 3,000 to 5,000 miners walked out of the mines. The leadership of the union was entirely Irish. They were asking for $1 more per day, better safety conditions, and the right to talk while they worked. Their leader was Dublin-born miner Michael Mooney. The strike was broken when Gov. Frederick W. Pitkin declared martial law in Leadville and sent in the Colorado National Guard.

Irish labor activism was not limited to Leadville. Mooney worked closely with another Dublin-born labor leader, Joe Murray, founder of the state's Greenback Party. Murray organized Colorado's first Knights of Labor assembly before running for Congress in 1886 on the Prohibition-Labor ticket. He remains a powerful symbol of 19th-century Irish radicalism in Colorado, once telling a group of workers, "The only great question today is one of classes—the producing poor, the idle rich."

Other prominent Irish American members of Denver's Knights of Labor included John B. Lennon and Joseph R. Buchanan. Lennon organized the Tailor's Protective Society of Denver in 1871. Buchanan published pro-labor newspapers in both Leadville (the *Crisis*) and Denver (*Labor Enquirer*) and was a leading figure in the Denver Knights of Labor.

Following the decline of the Knights of Labor in the 1890s, the Colorado Irish continued their leadership role. Irish-born Edward Boyce was a member of the Leadville Miners' Union and a founder and president of the Western Federation of Miners. The WFM and its Irish leadership led major strikes in both Leadville and Cripple Creek. In 1898, Boyce helped found the Western Labor Union, led in Denver by Irish American John C. Sullivan.

Legendary radical Mother Jones "raised hell" in Colorado twice. Born in County Cork, Mary Harris Jones lost her husband and four children to yellow fever before dedicating nearly 60 years to the fight for workers' rights, traveling across North America in support of striking miners and their families.

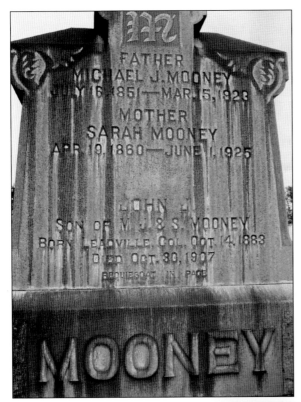

Michael J. Mooney, leader of the Miners' Cooperative Union, demanded that striking miners remain nonviolent and sober throughout the 1880 Leadville strike. Mooney was nearly lynched and then blacklisted from mining work in Leadville. He moved his family to Seattle and then Butte, Montana, where he again worked the mines. Mooney lived his final 19 years in Los Angeles with his wife, Sarah, and children. Sarah Gilgallon Mooney was the daughter of Irish immigrants from the Pennsylvania anthracite region. They are buried together in East Los Angeles in Calvary Cemetery. (James Walsh collection.)

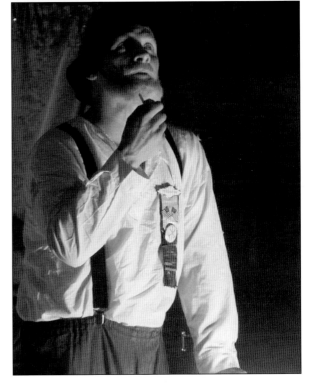

James Walsh portrays Michael Mooney as part of 2010 Romero Theater Troupe production *Which Side Are You On?* Walsh founded the Romero Troupe, named after martyred Salvadoran archbishop Oscar Romero, in 2005 to bring labor and working-class history to the general public. (James Walsh collection.)

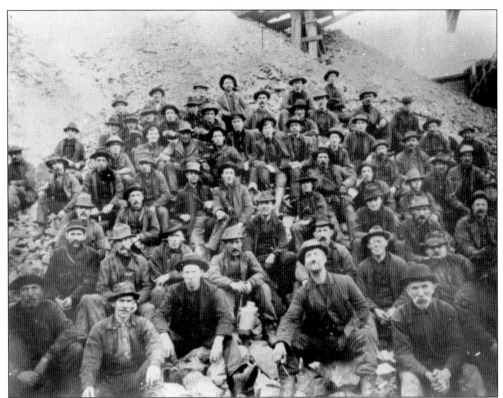

In the spring of 1880, after its owners reduced wages and ordered workers not to smoke or talk while on duty in Leadville's Chrysolite Mine, thousands of miners went on strike. Some scholars speculate that the owners deliberately provoked the strike so they would have an excuse for not paying irate stockholders who, like the miners, were being exploited. (James Walsh collection.)

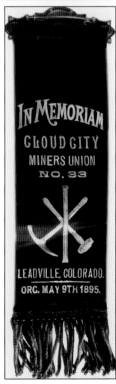

This commemorative ribbon for the Cloud City Miners' Union (CCMU) is one of the only physical remnants of early Colorado miners' unions. This union was involved in Leadville's Western Federation of Miners strike of 1896–1897, when as many as two dozen mostly Irish miners were killed. During the strike, labor spies infiltrated the CCMU and reported that the leadership of the union was almost completely Irish and that the Irish were the most radical members of the union. (James Walsh collection.)

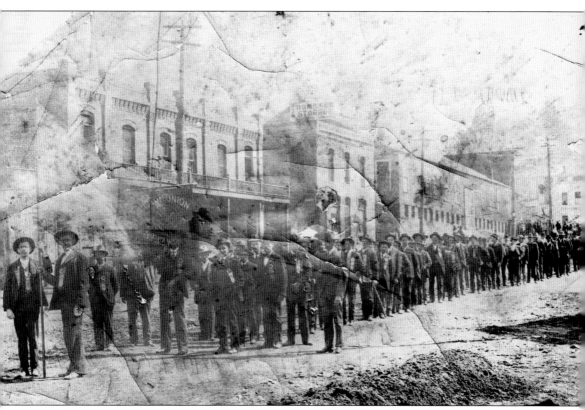

Striking Western Federation of Miners members are shown here marching in Victor. The Cripple Creek/Victor mines were heavily Irish. Note the union ribbons pinned to the miners' lapels. Two major strikes involving the Western Federation of Miners took place in Cripple Creek and Victor. (Sandy Oliver family photograph, James Walsh collection.)

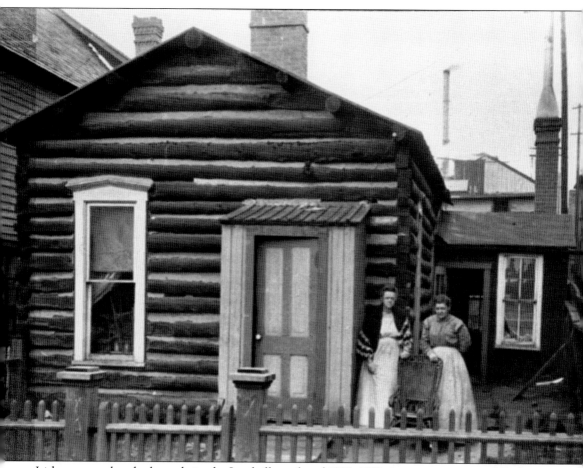

Irish women played a key role in the Leadville strike of 1896–1897. At one point, several Irish women blocked a road through the Irish district used by the National Guard to escort replacement workers to the Robert Emmett Mine. Gen. E.J. Brooks reported to Governor McIntire, "On each occasion when troops have escorted non-union miners to the mines . . . the women and children have heaped insulting and abusive epithets not only on the men, but on the Guards, 'Camelback scab herding sons of bitches' being one of the favorite expressions. The other epithets are too foul and vulgar to find a place in this report." (Colorado Mountain History Collection, Lake County Public Library.)

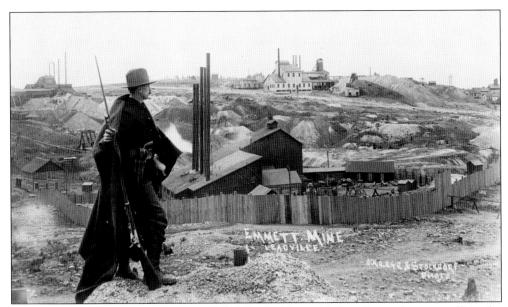

Many Colorado labor disputes were settled by the National Guard, seen here patrolling the Emmett Mine in Leadville during the 1896 strike. Typically, the guard protected mine owners, their mines, and "scab" labor. (Colorado Historical Society.)

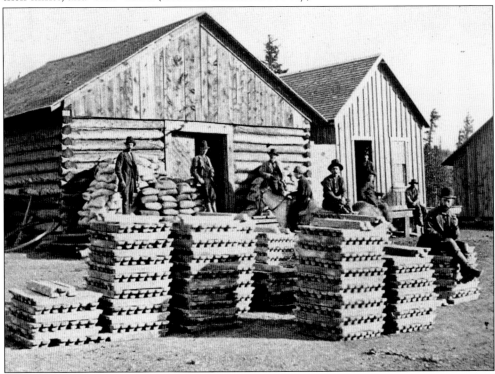

Leadville's mines poured forth fortunes in silver, shown here in ingots that were the final product of mining and smelting. Although the Leadville mines created many millionaires, including the Boettchers, Browns, Campions, Guggenheims, and Tabors, wages for miners were less than $3 for a 10-hour day. (Thomas J. Noel collection.)

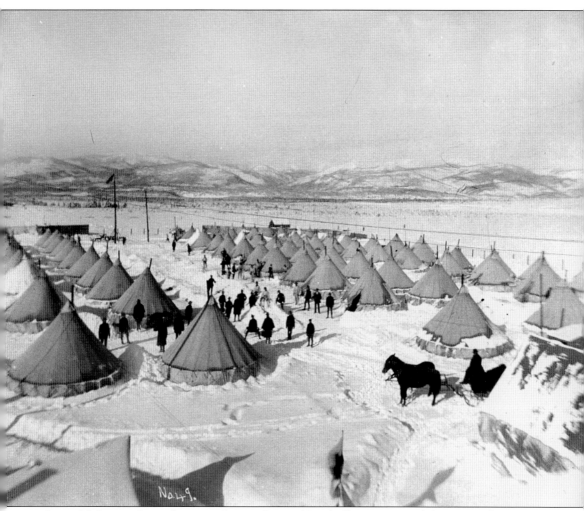

Camp McIntire, shown here on the outskirts of Leadville, was named for Gov. Albert W. McIntire. He broke the 1896–1897 strike by sending in the Colorado National Guard. (Denver Public Library.)

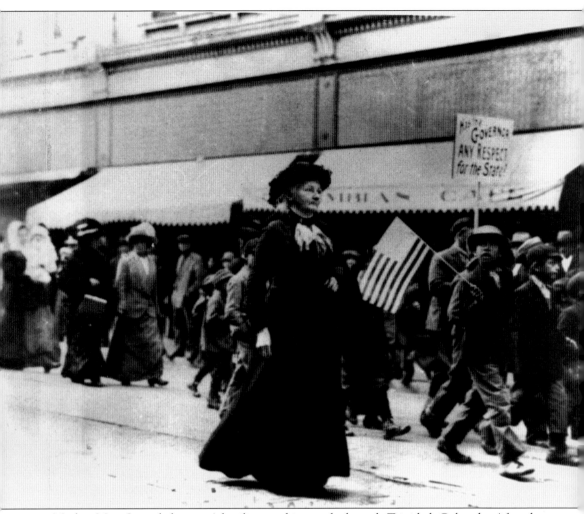

Mother Mary Jones led miners' families on this march through Trinidad, Colorado. After she was arrested and thrown into a Trinidad prison, over 1,000 women and children marched on her behalf. Colorado National Guardsmen charged the women on horseback, injuring many of them. In 1914, Jones was again "deported" out of Colorado, just before the infamous Ludlow Massacre, when members of the Colorado National Guard destroyed a tent colony of striking miners, killing mostly women and children. (Colorado Historical Society.)

Mother Mary Jones jumped into action when the WFM pressured the northern coalfield workers to accept a deal that would have excluded the southern coalfield workers. She traveled to Louisville to admonish the northern workers not to sell out their southern brothers: "You English speaking miners of the northern fields promised your southern brothers, seventy per cent of whom do not speak English, that you would support them to the end. Now you are asked to betray them, to make a separate settlement. You have a common enemy and it is your duty to fight to a finish. The enemy seeks to conquer by dividing your ranks, by making distinctions between North and South, between American and foreign. You are all miners, fighting a common cause, a common master. The iron heel feels the same to all flesh. Hunger and suffering and the cause of your children bind more closely than a common tongue." (Colorado Historical Society.)

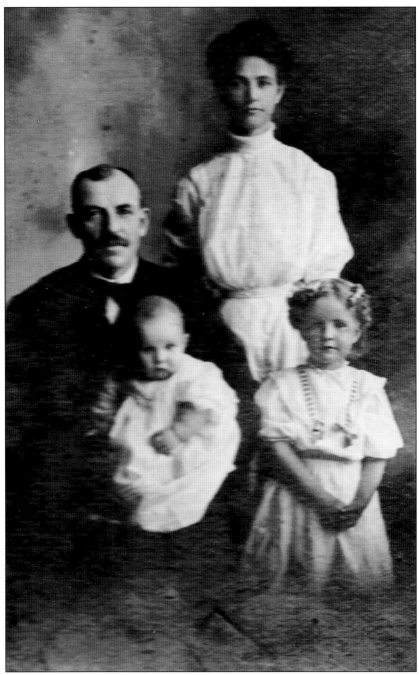

John Cornelius Sullivan poses with his wife, Annie Helen Mullins Rogers Sullivan, and their children. The son of Irish immigrants Dennis and Catherine Sullivan, John served as president of the Colorado State Federation of Labor from 1902 to 1905. He was known for his keen intellect and exhaustive research and pushed for the eight-hour workday in Colorado. Sullivan was targeted by numerous antilabor harassment campaigns, including incarceration, blacklisting, and confiscation of his property. On one occasion, paid goons put him on a train and dumped him in the middle of western Kansas. (Mary Rogers family photograph.)

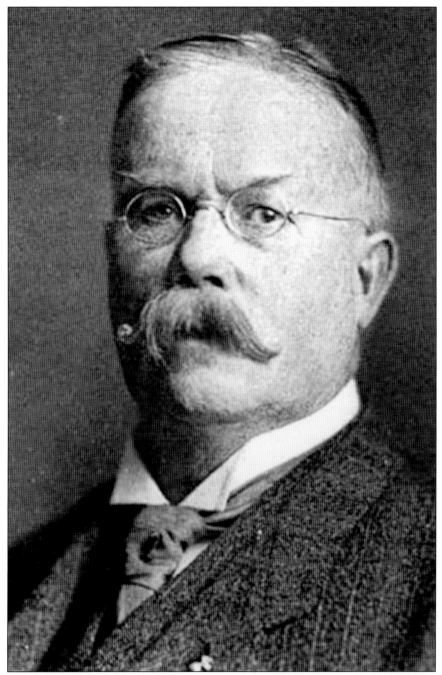

Irish-born James McParland gained fame and notoriety for claiming to have infiltrated the legendary Molly Maguires in Pennsylvania. His testimony led to the hanging of 10 alleged Mollies. Around 1890, McParland moved to Denver and headed the Pinkerton Detective Agency's Western Division. McParland spied on and unsuccessfully prosecuted William D. "Big Bill" Haywood and other Western Federation of Miners leaders for the murder of Idaho governor Frank Steunenberg in 1899. McParland weakened many strike efforts by infiltrating unions and stirring discontent among the ranks of striking miners and their families. (Blake Magner collection.)

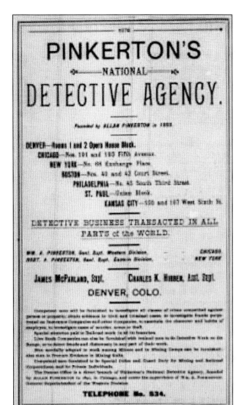

As this advertisement for the Pinkerton Detective Agency reveals, the Denver division, led by James McParland, had offices in the Tabor Grand Opera House, Denver's finest structure. Mine owner Horace Tabor, after his troubles with Leadville strikers, gladly offered the union-busting Pinkertons superb office space in his most famous property. (Blake Magner collection.)

In Leadville, agents from the Pinkerton Detective Agency were hired to infiltrate the Cloud City Miners Union during the strike of 1896–1897. Their detailed reports on the strike reflect the kinds of tactics used to disrupt, divide, and destroy the union. These tactics included dividing the union along ethnic and religious lines and spreading false rumors about union leaders. The reports also reveal a fear that the legendary Molly Maguires were still alive in Colorado mining camps. (Lake County Public Library.)

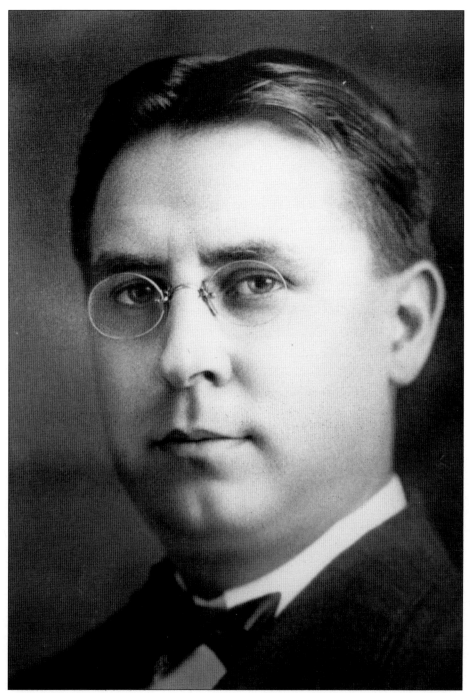

Edward Keating, the Denver-born-and-raised son of Irish immigrants, became a journalist and rose through the ranks to become managing editor of the *Rocky Mountain News*, which he left between 1912 and 1918 to serve in the US House of Representatives. As one of Colorado's first labor-friendly congressmen, he insisted that the federal government investigate the Ludlow Massacre of 1914, during which the Colorado State Militia had crushed the United Mine Workers strike. (Thomas J. Noel collection.)

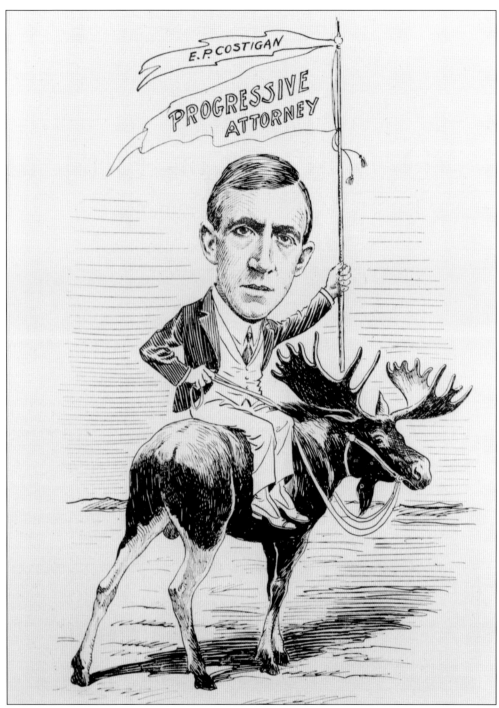

Edward Prentiss Costigan, US senator from Colorado between 1931 and 1937, successfully defended strikers accused of murder at Ludlow in 1914. In Washington, he supported New Deal labor legislation, such as the National Labor Relations Act, which tried to fairly arbitrate between management and labor. (Thomas J. Noel collection.)

Six

DAUGHTERS OF ERIN
IRISH WOMEN IN COLORADO

At the Ellis Island Immigration Museum in New York City harbor next to the Statue of Liberty, one of the many fascinating exhibits shows the numbers of male and female immigrants from each nation. The Irish were among the few to send as many women as men to the United States. The situation was so desperate back in potato famine Ireland that women as well as men made the difficult decision to leave their families. This was their only hope to avoid starvation.

These Irish women came by the millions to work in America as servant girls, nuns, barmaids, factory workers, or anywhere they could make a few dollars. Typically, they sent most of their meager earnings back to their families on the old sod. Like Celtic men, many of the women heard stories of silver and gold that lured them to mining camps, such as Leadville. One such poor, spunky girl became world famous—Margaret Tobin. She found and married a hardworking miner to become Mrs. James Joseph Brown, better known to the world as the "Unsinkable Molly Brown" of *Titanic* fame.

Another adventuresome Irish lass, the beautiful, shapely Elizabeth McCourt, caught the eye of Leadville's mayor and top silver tycoon, Horace Tabor. After a scandalous affair, she married him in Washington, DC, when he was a US senator. Pres. Chester Arthur was in attendance. The tragic conclusion of Colorado's most famous illicit love affair became one of America's most popular operas, *The Ballad of Baby Doe*.

Less known are the millions of women who married and raised families, sacrificing much so the next generation might succeed. Many other women became Catholic nuns who devoted their lives to educating and providing medical care for their communities. They helped to raise unfortunate children who wound up in Catholic orphanages and foster homes. Many females found work as domestic servants and offered to work longer hours if only they could be allowed one of their greatest comforts—time off on Sunday to go to Mass.

Irish women often worked as domestics after immigrating to America and earned a sterling reputation for their diligence. Such working-class women took advantage of these domestic settings to learn social etiquette and language skills from their mistresses. They returned to their more humble homes to install lace curtains and teach their children proper middle-class manners, thus turning their families into "lace curtain Irish." (Thomas J. Noel collection.)

Abby Klein and Julia Lucy came to Denver to work as domestic servants, a profession that Irish women used to raise their economic and cultural status. Even wealthy Irish, such as J.J. and Molly Brown, insisted on Celtic servant girls. (Karyl Klein family photograph.)

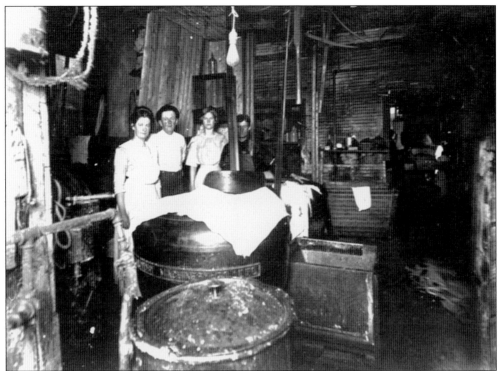

Irish women worked in Leadville and other mining camps as domestic servants, seamstresses, washerwomen, prostitutes, and boardinghouse matrons. Here, they are toiling in a Leadville laundry battling the consistent grime of a mining town. In 1870, two-thirds of employed Colorado Celtic women worked as domestic servants, where they often caught the eye of miners in this typically overwhelmingly male mining hub. The male-to-female ratio in these towns was often four or five to one. (Colorado Mountain History Collection, Lake County Public Library.)

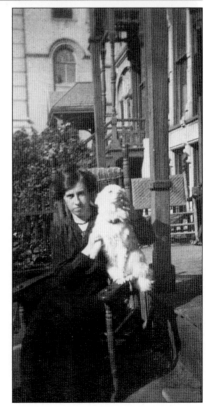

Just like other ethnic groups coming to the Mile High City, the Irish stayed wherever they could find their fellow countrymen. One of those special places where they could find a good home-cooked meal, find a clean bed, and hear other Irish brogues was Mrs. Purcell's Roominghouse on Curtis Street. The Romanesque windows and ornate quoin of Denver's auditorium theater can be seen in the background. Nora O'Donovan, shown here with her little dog Snow, came to Denver from County Cork. While living at Mrs. Purcell's, Nora worked as a domestic on Denver's fashionable east side. When asked who she liked working for the most, she smiled and answered, "The Jewish people, because they always let me go to church on Sundays." (Dennis Gallagher collection.)

Fitzgerald's Boardinghouse in Leadville, like many other such residences, was run by Celtic women. Many of these women were widowed by mining accidents and took in boarders to support themselves and their children. In this way, Irish women gained some social and political power. (Barbara Smith family photograph.)

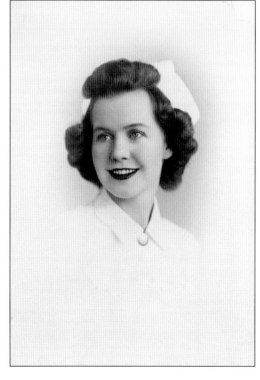

Many first-generation Irish girls found a higher rung on the ladder of the American Dream by heading to nursing school. Doris Gallagher attended Denver's St. Joseph Hospital's Mullen's School of Nursing, as did her sister Charlotte. Whereas first-generation Irish women worked primarily as domestics, second- and third-generation Irish Americans moved into professions such as nursing and teaching. (Dennis Gallagher collection.)

Margaret Tobin, born into a poor Irish family in Hannibal, Missouri, became the most famous woman in Colorado after heroically saving lives at the sinking of the RMS *Titanic*. Self educated, she traveled in top social circles in New York, Newport, and Europe. (Colorado Historical Society.)

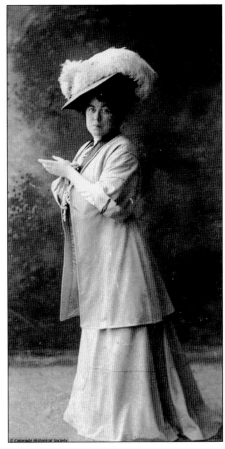

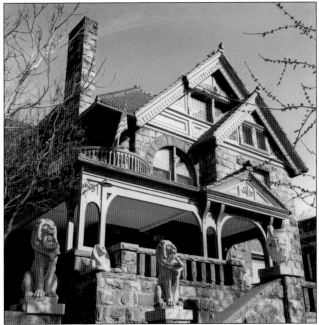

Molly Brown's House at 1340 Pennsylvania Street in Denver's Capitol Hill neighborhood is now the city's most popular house museum. Initially ostracized from high society as a nouveau riche Irish Catholic, she educated herself through study and travel. Today, she is celebrated as a poor immigrant who did well and worked for women's and workers' betterment. She has emerged as a role model for economically and socially challenged women. (Sandra Dallas, Denver Public Library.)

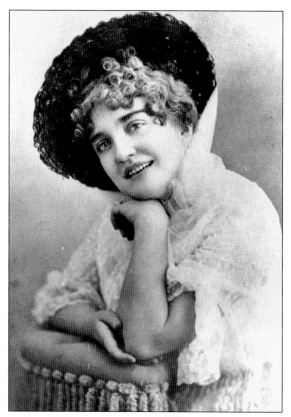

Elizabeth McCourt, an Irish Catholic beauty, married the richest and most famous man in Colorado after their scandalous affair. She later did penance for her sins, living as a hermit in the Matchless Mine outside of Leadville. There, on an icy March day in 1936, her body was found on the floor, frozen to death. A dozen books, a movie, and an opera have since immortalized Colorado's most adored adulteress. (Colorado Historical Society.)

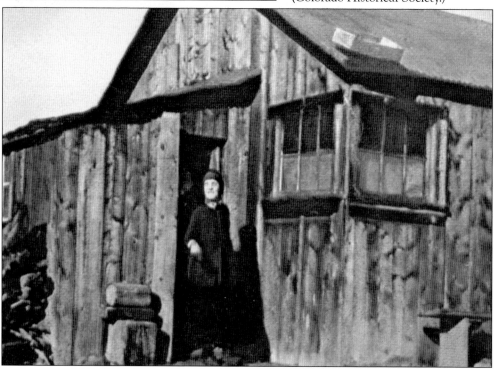

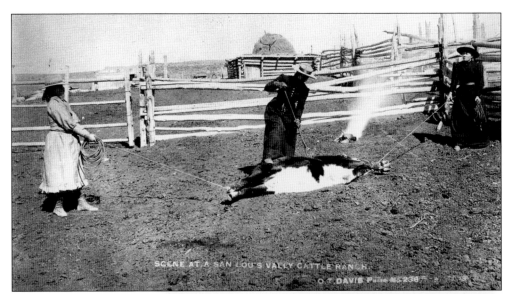

SCENE AT A SAN LOU'S VALLEY CATTLE RANCH
O. T. DAVIS Pano No. 238

Like all Colorado women, the Daughters of Erin often wound up running farms and ranches after their husbands died or disappeared into the mining camps. And they did this at a time when women wore only dresses—no pants—no matter how rough and dirty their tasks. (Colorado Historical Society.)

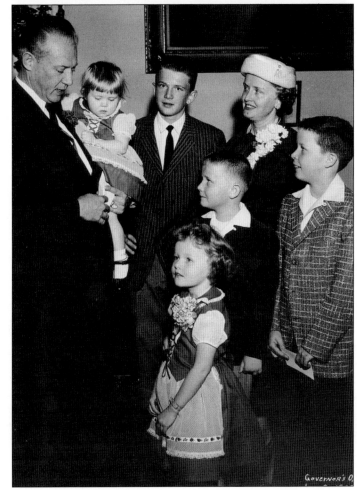

Marjorie McNichols, wife of Colorado's first Irish Catholic governor, raised a large family in the governor's mansion, dressing her children for public appearances and Sunday Mass. (Colorado Historical Society.)

Mary Coyle Chase, the daughter of an Irish-born mother, wrote the Pulitzer Prize–winning play *Harvey*, one of Broadway's most popular and longest running hits. In more than a dozen other comedies, this lifelong Denverite also satirized contemporary American life. Dorothy Parker, the famed humorist and writer, called her "the greatest unacclaimed wit in America." (Denver Public Library.)

Mary Lucy Downey, a Sister of Charity of Leavenworth and founding director of the Denver Archdiocesan Housing Program, Inc., oversaw a $30-million empire of federally subsidized housing for the elderly poor. (Photograph by James Baca; *Denver Catholic Register*.)

Kate Smith Mullen, the Irish-born wife of philanthropist J.K. Mullen, financed construction of the St. Joseph Hospital School of Nursing building, now a designated Denver landmark. The Sisters of Charity of Leavenworth ran both the nursing school and hospital. Sister Mary Andrew Talle served from 1963 to 1987 as administrator and chief executive officer of St. Joseph Hospital. The Sisters of Charity made this one of the largest and best hospitals in the state. Still growing, St. Joseph launched in 2011 a huge expansion on its central Denver site. (St. Joseph Hospital.)

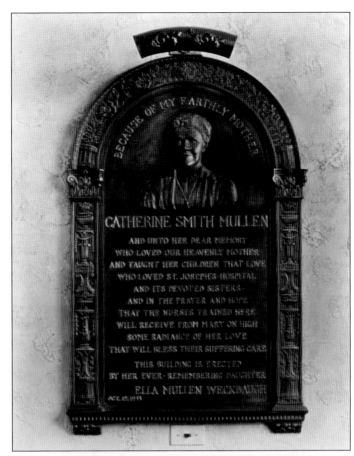

Hazel O'Shea lived with her family in a modest east Denver home at 1573 Ulster Street, where they rejoiced in their backyard view looking west to the spires of the Cathedral of the Immaculate Conception. She became a Sister of the Good Shepherd and worked at the Home of the Good Shepherd, a now demolished home for delinquent girls that stood at 1401 South Colorado Boulevard. (Dave O'Shea Dawkins.)

These three Sisters of Loretto were daughters of Denver police captain Martin J. Casey and his wife, Catherine Ryan Casey. Sister Menodora (Catherine Casey), Sister Edwina (Margaret Casey), and Sister Celestine (Josephine Casey) all pursued careers in the field of teaching. Sister Menodora was one of the first graduates of Loretto Heights and was a principal at St. Mary's Academy. She and her sister Margaret are both buried in the sisters' cemetery on the Loretto Heights campus. (Mary Ann Casey.)

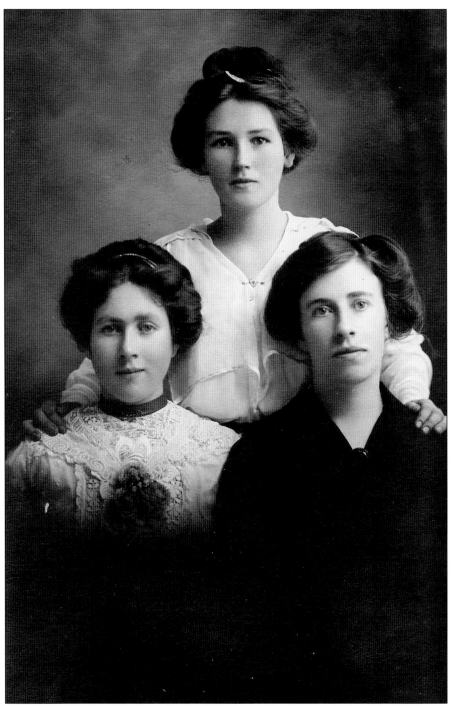

They called themselves "Greenhorns," Irish women arriving in Denver in the early 20th century from points east. Pictured from left to right are Ann Ahearn, Kitty Sweeney, and Nora O'Donovan. Kitty and Nora were from County Cork, while Ann was born in Belfast and found work in Denver as a secretary. Kitty took the train to Wyoming and married a rancher named Sullivan. (Dennis Gallagher collection.)

Seven

GET OUT THE VOTE
DENVER'S IRISH POLITICIANS

The Irish gravitated to the public stage and to politics.

Robert Morris became Denver's only Irish-born mayor, serving 1881–1883, despite an attempt by Democrats to turn Irish Catholics against Morris because of his religion and Republicanism. The ploy did not work. Celtic Catholic Denverites voted for one of their own. The election of Morris, as John K. Mullen noted, "united the Irishmen as they have never been united before."

From County Carlow came Thomas Patterson, owner and publisher of the *Rocky Mountain News*. Patterson served as Colorado's first US representative from 1877 to 1879 and as US senator from 1901 to 1907. A staunch Democrat, Patterson was one of the few newspaper editors to side with working people and the union cause. The *Rocky Mountain News* dominated Colorado media until the upstart *Denver Post* appeared in 1895, beginning a long and bitter newspaper war that did not end until the death of the *Rocky Mountain News* in 2009, just a month shy of its 150th birthday.

Martin D. Currigan served on Denver City Council from 1874 to 1900. His grandson Thomas G. Currigan was elected Denver auditor and was elected Denver's first Irish Catholic mayor in 1962. Another distinguished Celtic Catholic clan was that of William H. McNichols Sr., city auditor from 1931 to 1955. Stephen McNichols, the son of auditor McNichols, served as lieutenant governor and then as governor from 1957 to 1963. William H. McNichols Jr. occupied the Denver mayor's office from 1968 to 1983.

John Carroll, a Denver district attorney, became a US congressman from 1947 to 1951 and US senator from 1957 to 1963, before losing to a Republican Red Scare candidate who branded Carroll as a "pinko" Communist. Dennis Gallagher, a fourth-generation Colorado Irish Catholic, lost only one of 15 elections (the 1986 mayoral race). Gallagher served in the Colorado House of Representatives, the Colorado Senate, the Denver City Council, and as Denver city auditor (2004–2016).

Bill Owens became Colorado's second Irish Catholic governor from 1999 to 2007. Although the Irish have always been a small minority in Denver and Colorado, they have risen to prominence and popularity in political and public life.

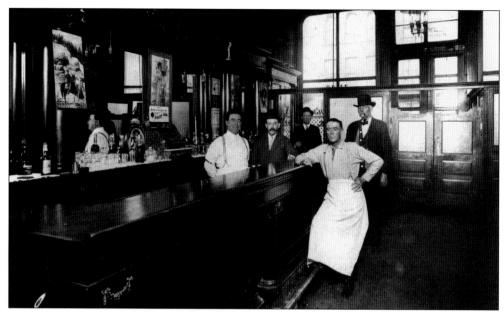

Longtime city councilman Eugene Madden ran Ward 1, the West Denver Auraria neighborhood, out of his saloon at 1140 Larimer Street. The mustachioed Madden, standing behind his bar, was a second-generation Irishman who walked every precinct in his ward, giving hugs to babies, sweets to the ladies, and food and coal to the needy. He attended practically every baptism, Holy Communion, bar mitzvah, wedding, and every funeral. For constituents, he bailed out relatives, found jobs and homes, and asked only to be remembered on election day. He served on city council from 1912 until his death in 1941. When queried by the *Rocky Mountain News* about all the voters registered at his saloon, Madden, with the grace of Peter Finley Dunne's Mr. Dooley, replied, "The homeless need an address from which to exercise their right to the franchise." In those good old days, voters were rewarded with dollars and drinks, helping voter turnout to often run over 100 percent. (Dennis J. Gallagher.)

Colorado's first great Irish character, Sligo, born Owen J. Goldrick, served as Denver's first schoolteacher. He rode into Denver in November 1858 wearing a top hat and tails, guiding his two oxen, Epimetheus and Prometheus, in Latin and Greek bovine instructions. According to William B. Vicker's 1880 *History of Denver*, Goldrick "walked up the street with an air so lordly that people looked at him as though he had just bought the town, and would take possession as soon as the papers were made out." He rented a little, sod-roofed log cabin along Cherry Creek near the Blake Street Bridge and in the fall of 1859 opened Colorado's first public school. Grateful Denverites elected him their first superintendent of schools. (Colorado Historical Society.)

Denver's Pillar of Fire Church, a bastion of the Ku Klux Klan, produced this propaganda cartoon. White-hooded Klansmen are chasing St. Patrick and snakes with labels such as "Rome in Politics" and "Anti-Prohibition" out of America. Irish Catholics became one of the main targets of the 1920 KKK revival. The Klan attacked the Irish as whiskey-soaked puppets of the Pope in Rome. (Thomas J. Noel collection.)

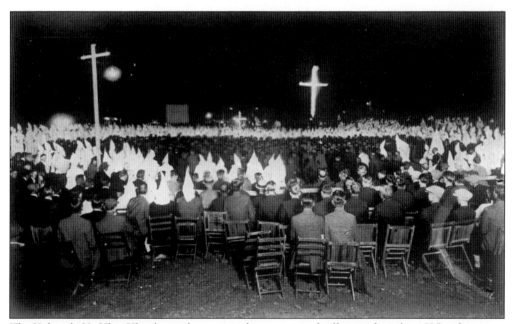

The Kolorado Ku Klux Klan burned crosses at their nocturnal rallies, such as this 1925 gathering in Denver. They also placed fiery crosses in front of Catholic churches and threatened to burn them down. Bishop Henry J. Tihen, who never lost his composure or his humor, responded: "There are one or two churches we would like to get rid of. Why not recommend these architectural scarecrows to the Klan crowd." In September 1925, after a cross was burned at St. Anne's Catholic Church in Arvada, over 10,000 Denverites marched from Regis University to St. Anne's on Fifty-second Avenue to speak out against the reign of the KKK. (Denver Public Library.)

Robert Morris, Denver's first Irish-born mayor, headed city government from 1881 to 1883. Morris defeated the German hardware dealer George Tritch in a contest suggesting that the Irish were fairly well accepted among non-Irish, who comprised more than 90 percent of the city's voters. (Denver Public Library.)

Thomas J. O'Donnell apparently passed on his fondness for tobacco to his sons, as seen here. A fixture in Democratic Party politics, he was one of the few to take on Frederick G. Bonfils and the *Denver Post*, which may explain why he never won an election. A pugnacious attorney, O'Donnell restored to fisticuffs as well as lawsuits in his many squabbles. (Denver Public Library.)

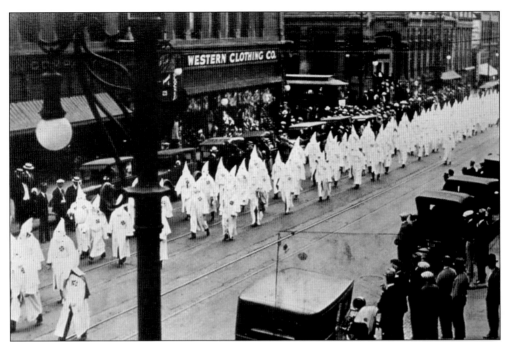

Members of the Ku Klux Klan march in downtown Denver. During the early 1920s, the KKK controlled much of Colorado, politically. The KKK directed much of its efforts at the Colorado labor movement and the Catholic Church. KKK strongholds in Colorado included Arvada, Golden, Longmont, Greeley, Boulder, Castle Rock, and Canon City. (Colorado Historical Society.)

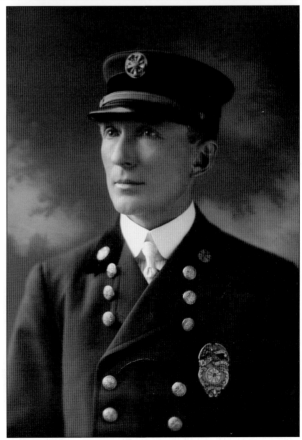

John F. "Jack" Healy was Denver's fire chief from 1912 to 1945. During the 1920s, politicians allied with the KKK were unsuccessful in removing the Catholic fire chief, due to his widespread popularity. It was said that Healy did such a fine job as chief that, if he were removed, local insurance agents threatened that Denver rates would have risen sharply. Healy persisted as one of the few top Catholic appointees to survive Mayor Benjamin Franklin Stapleton's KKK-inspired hit list. (Joanne Healy Sesson family photograph.)

Msgr. Matthew Smith, shown here with composition room foreman Wayne Kellerman, edited the *Denver Catholic Register*, which he used to counterattack the Ku Klux Klan by exposing the names behind the sheets. The very first edition of the *Register* was published in green ink, a not-so-subtle hint at its connection to the Irish community. (*Denver Catholic Register*.)

Colorado's first Irish Catholic governor, Stephen L.R. McNichols, left, tours Denver with the first Irish Catholic US president, John F. Kennedy, and Colorado lieutenant governor Robert Knous. (Stephen L.R. McNichols.)

Thomas G. Currigan, Denver's first Irish Catholic mayor, oversaw Currigan Exposition Hall, the ancestor of Denver's current Colorado Convention Center. It was named for this mayor, who pushed conventions and tourism—now Denver's number-two industry. (Berkeley Lainson Studios.)

William H. McNichols Jr., mayor of Denver from 1968 to 1983, initiated a citywide greenway program to transform trashy waterways into a series of cleaned up pedestrian/bicycle paths and parks. (Berkeley Lainson Studios.)

Dennis Gallagher, far right, and his students meet with Sen. Robert Kennedy in Washington, DC. Gallagher credits the Kennedy clan with inspiring him to go into politics and public service. (Dennis Gallagher.)

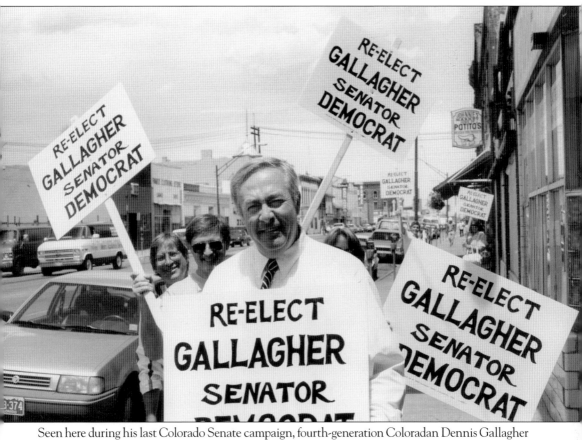

Seen here during his last Colorado Senate campaign, fourth-generation Coloradan Dennis Gallagher used old-fashioned oration, door-to-door campaigning, and one-on-one service to constituents to win house, senate, city council, and city auditor seats. One of the city's most popular public figures, Gallagher grew notorious for bursting into song when times turned dull or gloomy. A classics professor at Regis University, Gallagher elevated the public record and public discourse by quoting Shakespeare and classical Greek and Roman statesmen. The Gallagher Amendment to the State Constitution, passed by a popular vote in 1981, limits residential property taxes to 45 percent of the property-tax pie. (Thomas J. Noel collection.)

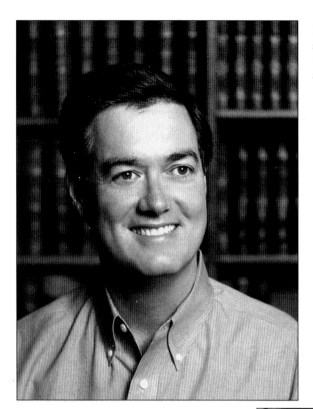

Bill Owens served as Colorado's second Irish Catholic governor from 1999 to 2007 and cut taxes and state expenditures. (Bill Owens.)

Denver district attorney Mitch Morrissey hales from an illustrious political clan. His grandfather Thomas J. Morrisey served as US attorney from Colorado, 1933–1947. In 1947, Thomas ran unsuccessfully for mayor. Mitch easily won election as Denver's district attorney. (Mitch and Maggie Morrisey.)

Eight

Visitors from the Old Sod
Prominent Visitors from Ireland

The high, dry, salubrious air of Colorado has long attracted visitors and settlers from the Emerald Isle. Michael Davitt, from County Mayo, founder of the Irish National Land League, came to the Mile High City and Leadville in 1880. His oratory inspired creation of the Denver Michael Davitt Branch of the League and an even larger Leadville branch.

The 1882 visit of Dublin-born Oscar Wilde, the famed playwright, critic, and aesthete also known for his scandalous romances, inspired the Brides of the Multitudes on Denver's Market Street. They adorned their bosoms with sunflowers and lilies to welcome Wilde, who lectured with similar flowers in his hair. Lt. Gov. Horace Tabor hosted Wilde to a catered dinner inside a Leadville mine. There, Tabor named a rich new shaft "The Oscar." Wilde, in his book *Impressions of America* (1882), described the subterranean supper: "The first course being whisky, the second whisky and the third whisky."

In more recent times, Irish presidents and Dublin mayors have come to Colorado. Robert Briscoe, the son of Lithuanian immigrants to Ireland and mayor of Dublin, made a most memorable visit in 1962. After a long lunch at Duffy's Shamrock Restaurant, he joined local Celts on a march around the block to inspire reinstatement of the annual St. Patrick's Parade. When Robert retired as mayor of Dublin in 1965, he was succeeded by his son Brian. In the thousand-year list of Dublin mayors, the Briscoes are the only father and son and the only Jewish lord mayors of Dublin. When Mayor Brian Briscoe came to Denver in 1988, the Irish and Jewish community hosted a lunch that raised $15,000 for a new organ at the Dublin Concert Hall. A smiling Mayor Briscoe, bridled with the Dublin mayor's gold chain, presented Rabbi Manual Laderman with a green yarmulke from the chief rabbi of Dublin. Speaking for all Irish visitors, Mayor Briscoe thanked Coloradans for their hospitality and urged that the United States allow even undocumented Irish to stay and gain citizenship.

County Cavan–born Thomas "Broken Hand" Fitzpatrick, a famous early Colorado Mountain man and Indian agent, was respected by the Arapaho for his fair treatment of Native Americans. He was among many Irishmen who wound up on the cutting edge of the American frontier. (Colorado Historical Society.)

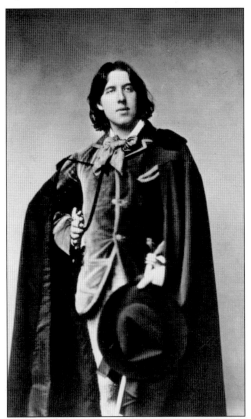

Oscar Wilde, the most celebrated Irishman to visit Colorado, gave lectures in Denver and Leadville in 1882 on "Interior and Exterior House Decoration as Applied to Our Modern Houses." Wilde's talk in Leadville at the Tabor Opera House was delayed, he claimed, by the trial and lynching of two murderers. Actually, that happened three years earlier. Wilde also saw violence in Leadville saloons, where he noted that a musician had posted the plea, "Please do not shoot the pianist. He is doing his best." Wilde called this "the only rational method of art criticism I have ever come across." Irish intellectuals particularly prized Wilde, as fellow Irish author William Butler Yeats put it, for launching "an extravagant Celtic crusade against Anglo-Saxon stupidity." (Thomas J. Noel collection.)

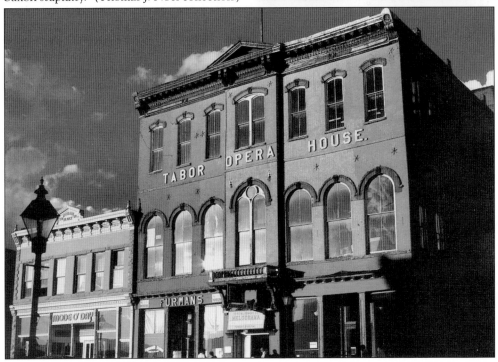

Michael Davitt, founder of the Irish Land League, visited Denver and Leadville in October 1880 and 1886. Inspired by Davitt, Denverites, and Leadvillites, each formed an Irish Land League chapter, including a Ladies League in Leadville. With the slogan "the land for the people," the league encouraged the Irish poor to fight for redistribution of land in Ireland. In 1881, Irish miners in Leadville contributed more to the land league than any other city in the nation except Chicago and Philadelphia. The Colorado mining camps, particularly Leadville, were considered fundraising gold by prominent Irish nationalists and politicians. During the 1880s and 1890s, dozens of Irish dignitaries made their way to Leadville to raise funds to support Irish nationalist causes. (Blake Magner collection.)

For over 1,000 years, Dublin has been keeping records on who wears the gold chain, the symbol of lord mayors. This 1989 picture is of Dublin's second Jewish lord, Ben Briscoe, the son of former Jewish lord mayor Robert Briscoe. It is believed that the Briscoes served as the only father-and-son team for Dublin's mayors. Ben visited Denver in 1989 to raise funds for an organ at Dublin Concert Hall. Mayor Ben Briscoe gave Rabbi Manual Ladermann of Denver's Hebrew Educational Alliance a green yarmulke made in Ireland. Ben Briscoe succeeded his father and served his Dublin constituents for 37 years. Dublin voters elected Robert Briscoe repeatedly, and he served for 38 years. On April 17, 1962, on Robert's visit to Denver as lord mayor, he led a march out of Duffy's around the block, thus helping to inspire the resurrection of Denver's St. Patrick's Parade. (Chris Leppek for the *Intermountain Jewish News*.)

John Lawrence Sullivan, the most pugnacious of all the "fighting Irish," fought in Leadville in 1883 and 1886, defending his world heavyweight championship title. In 1883, the *Leadville Evening Chronicle* described the champ as he entered the ring as "in a condition that the vulgar would call drunk." Three years later, Sullivan returned to fight again in Leadville and told the crowd, "When I was here three years ago I was drinking all the time; now I'm not drinking at all." As recently as 2006, boxing matches took place in Leadville saloons. (Blake Magner collection.)

William Harrison "Jack" Dempsey was born in Manassa, Colorado in 1895 to parents of Irish and Cherokee descent. Known as the Manassa Mauler, Dempsey held the world heavyweight boxing title from 1919 to 1926. Dempsey was known to pack one of the most powerful punches in the history of the sport. (Thomas J. Noel collection.)

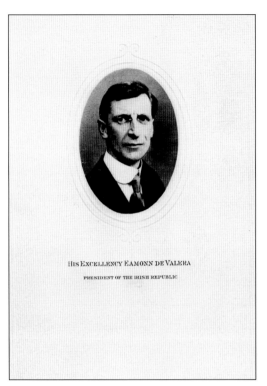

HIS EXCELLENCY EAMONN DE VALERA

PRESIDENT OF THE IRISH REPUBLIC

Colorado Celts celebrated the 1919 visit of Eamonn de Valera, president of the Irish Republic, with a gala at Denver's Brown Palace Hotel. (Both, Brown Palace Hotel historian Debra B. Faulkner.)

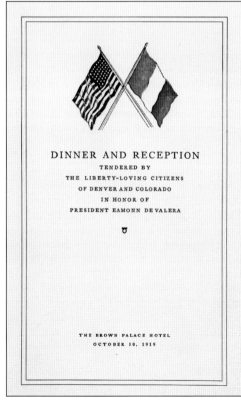

DINNER AND RECEPTION

TENDERED BY
THE LIBERTY-LOVING CITIZENS
OF DENVER AND COLORADO
IN HONOR OF
PRESIDENT EAMONN DE VALERA

THE BROWN PALACE HOTEL
OCTOBER 30, 1919

INVOCATION
Rev. William S. Neenan

WELCOME TO DENVER
Dewey C. Bailey
Mayor of Denver

WELCOME TO COLORADO
Hon. Oliver H. Shoup
Governor of Colorado

WELCOME BY A NATIVE SON
OF COLORADO
Hon. Charles T. Mahoney

AMERICAN IDEALS IN IRELAND
Hon. John B. McGauran
Surveyor General of Colorado

IRELAND'S HOPES AND AMBITIONS
Hon. Eamonn de Valera
President of Ireland

BENEDICTION
Right Rev. John Henry Tihen
Bishop of Denver

TOASTMASTER, John Leo Stack

BANQUET
IN HONOR OF PRESIDENT EAMONN DE VALERA

· · ·

GRAPEFRUIT FRAPPE
CELERY OLIVES

· · ·

STRAINED MARMITE

· · ·

ROAST STUFFED SPRING CHICKEN
GIBLET SAUCE
POTATOES RISSOLE
FRENCH STRING BEANS

· · ·

LETTUCE AND TOMATOES
FRENCH DRESSING

· · ·

BISCUIT A LA DeVALERA
ASSORTED CAKES

· · ·

DEMI TASSE

Music

THE BROWN PALACE HOTEL · OCTOBER 30, 1919

Irish president Eamonn de Valera received a royal welcome in 1919 to Denver's Brown Palace Hotel, draped for the occasion in festive green, white, and orange banners. After de Valera's speech, enthusiastic local supporters hosted a bond sale for the fledgling Irish Republic. Prominent Irish visitors from de Valera to Pres. Mary McAleese have stayed at Denver's grand old Brown Palace Hotel, open every single day since its 1892 debut. The *Denver Times* article details events surrounding de Valera's 1919 visit to Denver: "For today Denver is the temporary capital of Ireland and the Brown hotel the headquarters of the 'republic's chief executive.' " De Valera was described as "a quiet, mild-mannered, studious appearing man, almost shy in his manner, until he starts talking about Ireland, when he reveals a remarkable magnetism and personality." Denver radio stations refused to give him airtime or even recognize his visit. (Brown Palace Hotel historian Debra B. Faulkner and Colorado Historical Society.)

15395. Brown Palace Hotel
Denver, Colo.

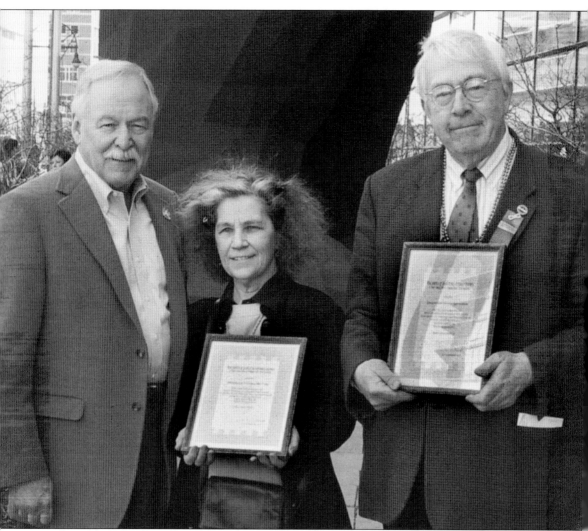

Denver's first honorary Irish consul, James Lyons (left), went to law school with Bill Clinton at Georgetown University. President Clinton appointed Lyons as his special ambassador to the Northern Ireland peace talks, which ended with the 1998 Good Friday Accords. In this image, Lyons presents an award from the Irish Tourist Board to Regis University professors Victoria McCabe and Dennis Gallagher for their heroic efforts in shepherding flocks of Regis University undergraduates to Ireland's historic, literary, and holy sites. In their annual summer pilgrimages since 1992, McCabe and Gallagher have encouraged over 300 Regis students "to forge on the smithy of their souls the uncreated conscious of the Irish people," to paraphrase Stephen Daedalus in Joyce's *Portrait of the Artist as a Young Man*. (James Walsh collection and Regis University.)

Although James Joyce never visited Colorado, the Irish literary lion is honored here. The James Joyce Reading Society, founded in Denver in 1982, meets monthly in one of the 125 member's homes to read Ulysses and other Irish literary masterpieces. That society collaborated with Regis University to install this statue on the Regis Campus of the foremost novelist of the 20th century. Joyce fans also annually host a Joycean float in Denver's St. Patrick's Day Parade. (Dennis Gallagher.)

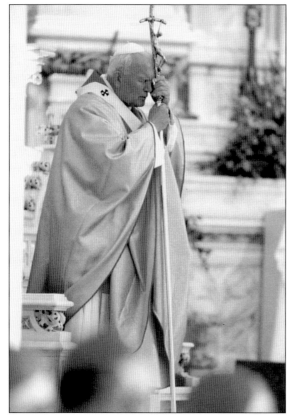

Ireland's U2, said to be this planet's most famous rock band, performed, despite a thunderstorm, at Red Rock Amphitheatre on June 5, 1983. This "Soggy Sunday" concert is considered one of Colorado's musical highlights. (Denver Theatres & Arenas.)

Youngsters from Ireland joined the many youth from all corners of the globe convening in Denver for World Youth Day with Pope John Paul II in August 1993. Over 100,000 thronged Cherry Creek State Park for a Mass there, and some also squeezed into Immaculate Conception Cathedral for this papal Mass. (Photograph by James Baca; *Denver Catholic Register.*)

Mary McAleese, the president of Ireland, visited Denver in 2006 and toured Regis University where she chatted with Regis president Michael Sheeran, SJ, about joint economic programs. (Regis University.)

Irish visitors often wind up in Scruffy Murphy's Irish Pub at 2030 Larimer Street in Denver, a haven for the food, drink, and music of the Emerald Isle. (Thomas J. Noel collection.)

Noel Cunningham, left, opened his popular restaurant Strings in 1986 in east Denver. Cunningham, born in Dublin, never forgot his rough-and-tumble working-class roots, even though now the rich and famous hobnob at his dining hall, making it the place to be and be seen. This image shows Fr. Michael Sheeran, SJ, right, president of Regis University, awarding Cunningham the university's highest honor, the Civic Princeps Award (First Citizen Award) for his many philanthropic works. Cunningham has raised many thousands of dollars for Ethiopia Reads, a literacy and library project. Every Mother's Day, Cunningham opens his restaurant to any mother in Denver who has no one to share a meal with on her special day. Upon receipt of his award from Regis, Cunningham reminded faculty and students, "You don't have to hold a PhD to be generous to others."

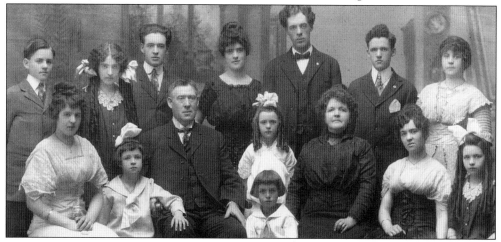

This 1916 photograph captures the family of Michael Dennis Nevin and Mary Nevin, front center, who immigrated to Leadville from Ireland in the 1880s and later moved to Denver. Michael was an explosives expert. Mary worked as Margaret Tobin's (Molly Brown's) first domestic and served a meal to Irish president Eamon de Valera. De Valera repaid their hospitality by sending a print from the Vale of the Avoca in County Wicklow, where Mary was born. At the front center of the photograph is Michael and Mary's youngest son, Thomas Nevin, who served in the Colorado State House of Representatives and was a Grand Knight in the Knights of Columbus. Thomas Nevin's children continue to run Shamrock Realty, a business that he started. (Kelly Mansfield family photograph collection.)

Nine

ONGOING IRISH TRADITIONS
ONWARD AND UPWARD

Colorado is home to a gold mine of Irish clubs, concerts, arts, music, and festivals. One way to keep track is the website www.CelticConnection.com, which introduces readers to Irish personalities, events, gift shops, books, and announcements. These range from Miriam Rosenblum's Irish tin whistle class to Mick Bolger's Irish language class. Connections include witchcraft and pagan pages, with online stores for Wiccan books, jewelry, and magic supplies as well as more traditional goods and services.

The *Celtic Connection* started out in 1993 as the newsletter of Nallen's Pub, one of more than 30 Irish watering holes statewide. Many of these watering holes sponsor Irish music sessions, dances, readings, and other Celtic celebrations. Such Gaelic groggeries are also hangouts for the bagpipe bands that grace the mountains and plains with their stirring strains. The Ancient Order of Hibernians sponsors the Michael Collins Pipe Band, while the Colorado Youth Pipe Band introduces music, dance, and culture to youngsters. The City of Denver Pipe Band is popular, as is the Emerald Society Pipe Band, which gives fire and law enforcement personnel opportunities to let off steam by playing the pipes. First established by New York City policemen in 1953, the Emerald Society has since spread to more than 50 other cities, including Denver.

Colorado boasts at least 15 different Irish societies, ranging from the Irish American Cultural Institute to the Irish Fellowship Club of Colorado (IFC). The IFC was formed in 1962 with the leadership of brothers Louis and Vincent Walsh. The club met at Duffy's Bar and enlisted proprietor Bernard Duffy and star *Denver Post* columnist Red Fenwick in its vigorous campaign to reinstate the St. Patrick's Day Parade in 1963.

Every July since 1994, the Colorado Irish Festival has grown to embrace an ever-larger audience and assortment of all things Celtic. The Denver Gaels sports team has been spreading Irish culture since the 1990s by offering men's and women's sports with games of Gaelic football and hurling. Irish culture and literature are enjoyed and shared by Denver's James Joyce Reading Society, which has been meeting and reading in members' homes ever since 1982. Edmund F. "Ned" Burke and Robert Ross founded this Denver society in the back room of Sullivan's Bar on Court Place. So, the Irish in Denver today are striving, along with Stephen Daedalus in Joyce's *Portrait of the Artist as a Young Man*, to forge greater Irish consciousness.

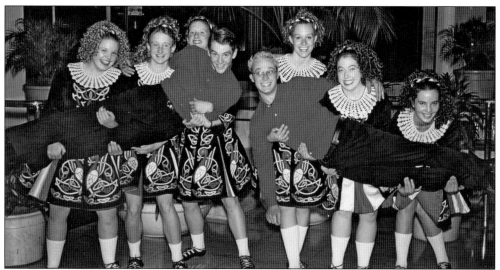

The McTeggart family of County Cork has blessed America with premier Irish step-dancing teachers. Peggy McTeggart founded the school in Cork in 1939. Maureen McTeggart Hall, Peggy's sister, came to the United States in 1958 and founded McTeggart Irish step dancers with five schools in Colorado and others in Alaska, Kentucky, Louisiana, Oklahoma, and Texas. The dancers' dresses are embroidered with intricate patterns from the *Book of Kells*. Linnane Wick, one of Maureen's brightest students, founded her own school, the Wick School of Irish Dance, in Denver. Today, the Denver area boasts more than eight other schools of Irish dance for kids and adults. Thanks to Maureen and countless other Irish dance teachers, Denver has become a national hub for Irish step-dancing competitions. Thousands of youngsters in Colorado have learned the intricacies of Irish dance and, as a result, much about the culture of Ireland. In this image, McTeggart Step Dancing lasses hoist two dancing lads aloft during a break at a dance festival in 2000. Second from the right is Meaghan Kathleen Gallagher. (Dennis Gallagher collection.)

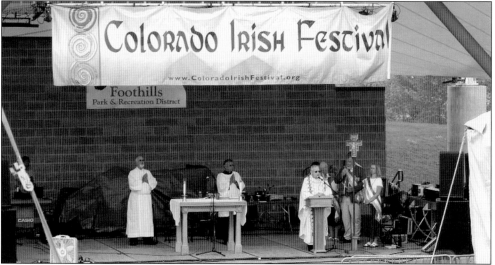

The Colorado Irish Festival, held every July since 1994, offers Irish music, bagpiping, step dancing, food, and merriment. This three-day-long Celtic celebration is held in Littleton's Clement Park and includes hurling, camogie, and Gaelic football. As shown here in 2011, the festival also includes a Catholic Mass. (Colorado Irish Festival.)

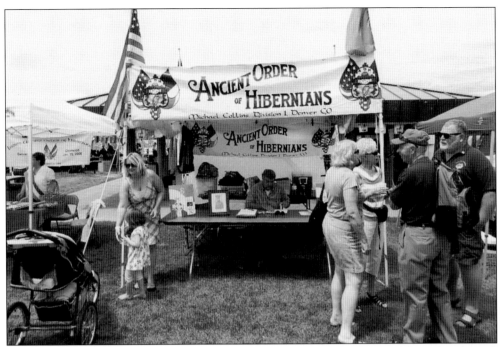

Denver's Ancient Order of Hibernians, founded in 1889, is a major sponsor of the Colorado Irish Festival. The Hibernians also award prizes for the best student research paper on the Irish in Colorado. (Colorado Irish Festival.)

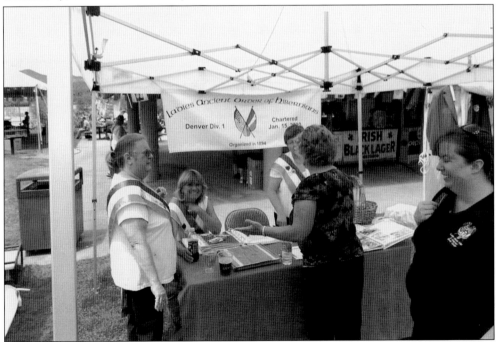

Colorado women in 2000 established their own chapter of the Ancient Order of Hibernians. Lassies as well as lads have led the wonderful Colorado Celtic cultural renaissance in recent decades. (Colorado Irish Festival.)

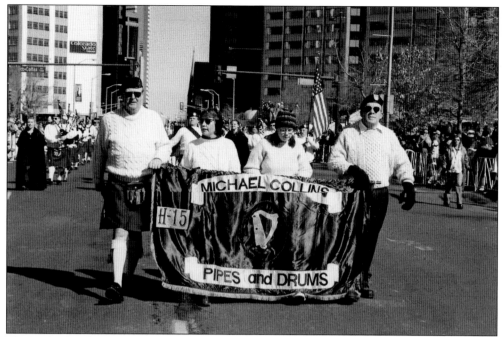

The Michael Collins Pipe Band claims to be the oldest and best in Colorado. It has long been a favorite of St. Patrick's Day Parade spectators. (Visit Denver: The Convention & Visitors Bureau.)

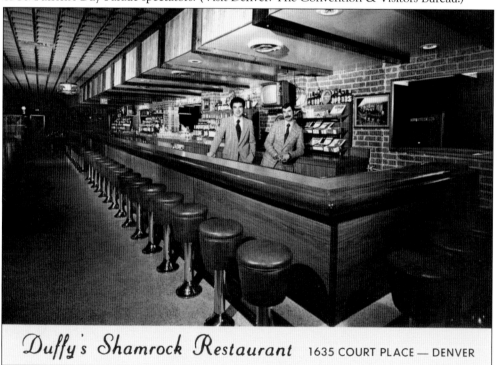

Duffy's Shamrock Restaurant 1635 COURT PLACE — DENVER

Ken and Frank Lombardi ran Duffy's, which had the longest bar (72 feet) in town, for decades. The most legendary Irish bar in the Rockies attracted huge crowds, especially on St. Patrick's Day, until it closed in 2006. (Thomas J. Noel collection.)

I'M Out For The Night

If I get drunk, tie this tag to my buttonhole
and send me home.

Name: Tom Noel

Address: 1245 Newport
Montclair

**DO NOT KNOCK, BUT RING THE BELL AND WHEN
THE MRS. COMES, RUN LIKE HELL!**

To help tipsy customers, Duffy's issued these name tags on St. Patrick's Day. Lines extended around the block as the crowd waited for someone to finally leave before the next person could get into the jammed-packed party and Celtic rites inside. (Thomas J. Noel collection.)

I'm Out For The Night

at the best Irish place in Denver

Duffy's Shamrock

1635 COURT PLACE — DENVER

Happy St. Patricks Day

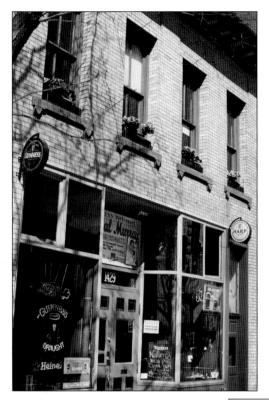

"I left Ireland on holiday and couldn't afford to go back," recalls John Nallen. He stayed in Denver and, in 1992, opened Nallen's Irish Pub, which claims to sell more Guinness than any other Colorado pub and which offers Irish storytelling and music. Pat McCullough began doing Nallen's newsletter in 1993. It became a one-page newsletter of Irish events and evolved into a newspaper and website, the *Irish Connection*, promoting not only Nallen's but also all things Irish. (Thomas J. Noel collection.)

Neal Cassady, a wild Denver Irishman, was a colorful car thief and skirt chaser lionized in Jack Kerouac's famous novel of the beat generation, *On the Road*. Here, Neal, right, poses with Jack, left, on one of their many road trips. (City Lights Book Store, San Francisco.)

At this Irish Fellowship Club of Colorado (IFCC) dance in 1981, the musicians are, from left to right, Liz Mitchell on flute, Bill Leuthauser on piano accordion, Pat Flanagan on button accordion, Tony Keenan on drum, and Mary Flanagan on mandolin. Pat and Mary Flanagan made invaluable cultural contributions to Denver's Irish community. Pat, born in 1914 in Chicago to an Irish-speaking household, was the "grand old man" of Irish ceili band music for decades in Denver and his field recordings are in the Library of Congress. Mary was born in County Mayo in 1922. They both came to the United States in the 1950s and opened their home to countless musicians traveling through, including Joe Burke, Paddy Glackin, Kevin Burke, and Scottish national fiddle champion Johnny Cunningham. Irish traditional musicians all over the United States and Ireland know of his reputation as a rock solid player and teacher. Pat played the button accordion upside down and backwards due to the effects of polio. (John Nielson.)

At the 1982 Irish Fellowship Society St. Patrick's Day Dance at Christ the King Church, Ann Hession celebrates with her father, Jack. (Anne Hession family photograph.)

Common Grounds coffeehouse in northwest Denver is described by its owner as "pubby." This coffeehouse (which also serves beer and wine) is run by the descendants of John C. Sullivan, president of the Colorado Federation of Labor, and remains one of the last remaining family-run institutions in Denver today with a Celtic theme. According to the Rogers family, owners of Common Grounds, "We're working-class people who started a working-class business. We come from a long line of people who are concerned with community. It was important to us from day one to pay our staff well, to support community members, to make this an honorable profession and a good place to work." Common Grounds has frequently been a center for political activity in northwest Denver, with visits by Jerry Brown in his 1992 presidential campaign and Hillary Clinton during the 1996 campaign. (Mary Rogers family photograph.)

John "Jack" Francis Healy was born at his grandmother's house December 3, 1903, in Denver and grew up in the Curtis Park neighborhood. He was the son of John P. Healy, who served as Denver's fire chief for more than 40 years. He attended Regis High School and was a standout athlete on the football, baseball, and boxing teams at the University of Colorado during the mid-1920s. At CU, Jack was selected as an all-conference end in 1923, 1924, and 1925. The 1924 team remained unbeaten, untied, and unscored upon. (Joanne Sessons family photograph collection.)

John F. Healy's talents were not limited to the athletic fields. During his years at CU, he was very active in the theater department. Healy was also a regular on stage at the Bonfils Theater, Denver Civic Theatre, and Elitch Gardens Theatre. He appeared in such productions as *Green Grow the Lilacs*, *The Rainmaker*, *Cat on a Hot Tin Roof*, and *Harvey* with Joe E. Brown and *Another Part of the Forest* with Joan Van Ark. According to family lore, John once snuck into a KKK meeting at night and hid among the cars, taking the license plate numbers of the Klansmen in order to identify them. (Joanne Sessons family photograph collection.)

Pictured from left to right, Mick and Jean Bolger, Mike Fitzmaurice, Cynthia Jaffe, and Brian Mullins make up one of Colorado's most dynamic traditional Irish bands today. Colcannon has developed a distinctive, inventive, and contemporary musical style while still keeping in firm touch with the soul of traditional Irish music. Colcannon's concerts are renowned for their energy and for singer/front man Mick Bolger's irrepressible sly wit. Their music expresses flights of joy and deep sorrows and yet focuses on the beautiful wealth of traditional Irish music. With all acoustic instrumentation and traditional as well as original tunes and songs, Colcannon's message is the story of the resilient and joyous human spirit. The band formed in 1984 in Boulder, Colorado, and their reputation has grown steadily with the release of eight CDs on the Oxford Road Records label. The Emmy Award–winning PBS special *Colcannon in Concert*, filmed at the Denver Center for the Performing Arts, has aired nationwide. (Mick Bolger collection.)

Gobs O'Phun is an Irish/Scottish acoustic folk trio that performs traditional Celtic folk songs. They accompany themselves with guitar, bodhran, sticks, banjo, and the awe-inspiring instrument not found in any other band—"bagmonica"—their own humorous take on the bagpipe. Gobs O'Phun is made up of brothers Denis and Tim Sullivan, along with one of their brothers-in-law, Martin Lambuth. All three grew up in Pueblo, Colorado, where they formed the group in 1994. (Gobs O'Phun photograph collection.)

Legendary traditional Celtic musician Pat Flanagan is pictured in 1981. Pat played the button accordion upside down and backwards. He was a "top player" in Denver's traditional music scene. (John Nielson photograph collection.)

Margaret McBride, shown here playing Irish jigs and reels on her penny whistle in 1981, is a central figure in the traditional Celtic music scene. Margaret is nearly 90 and still playing. (John Nielson photograph collection.)

Fr. Michael Sheeran, SJ, headed until 2011 the largest Catholic institution of higher learning in the Rocky Mountain Region, Denver's Regis University. His successor, Fr. John Fitzgibbons, another Irish Jesuit, took charge of the Denver campus with its 16,000 students in 2012. (Regis University.)

Ten

St. Patrick's Day Parade
Denver's Annual Spring Ritual

Foremost of Colorado's Celtic rituals is Denver's St. Patrick's Day Parade. Robert Morris, Denver's first Irish mayor, sanctioned the city's first St. Patrick's Day parade in 1883. A chief collaborator, Fr. Joseph P. Carrigan, the charismatic pastor at St. Patrick's Church, staged St. Patrick's Day fundraising galas with costumes and bagpipers, song and dance, and marching.

Mayor Robert W. Speer made the parade official in 1906 with encouragement from the Ancient Order of Hibernians and Daughters of Erin. That parade ended up not in a saloon but in a church for High Mass and Fr. William O'Ryan's sermon on "Ireland's Loyalty to Patrick's Faith."

Such festivities went out of style during the 1920s, when anti-Catholic, anti-immigrant outfits such as the Ku Klux Klan suppressed the parade. Not until 1962 did devotees of St. Patrick meet at Duffy's Shamrock Bar & Restaurant at 1635 Court Pace. This being an Irish matter, there are disputes: some say it was Sullivan's Bar at 1435 Court Place. Red Fenwick, cowboy columnist for the *Denver Post* and some of his "Evil Companions Club" were involved in propelling the parade. The *Denver Post* reported that "it was a short march: the paraders walked out of Duffy's Shamrock Restaurant, went around the block, and back into the bar." Others claim that the modern parade came a month later, April 17, 1962, when Lord Mayor Robert Brisoe of Dublin lunched with Irish Americans at Duffy's and spearhead a similar mini procession.

Louis Walsh, head of the Irish Fellowship, persuaded Jim Eakins, who had organized Denver's American Legion parades since 1956, to chair an official parade committee to plan the 1963 festivities. It drew thousands of marchers and spectators and grew in subsequent years to be second in size only to New York City's. By 1974, according to the *Denver Catholic Register*, Denver's parade "drew a crowd estimated at over 120,000 people."

Denver's parade has since thrived, bringing business downtown and cheering up the city on the often nippy Saturday closest to March 17, the day St. Patrick died in the year 461. It attracts every conceivable ethnic group, even the English, starting at 10:00 a.m., rain, snow, or shine. On St. Patrick's Day, everyone is invited to be Irish.

St. Patrick's Day Parade balloons, bunting, and shamrocks galore adorn Denver for one of the largest such parades nationwide. (Thomas J. Noel collection.)

30th Anniversary Review
St. Patrick's Day Parade Founder and Presidents

JAMES P. EAKINS was founder and chairman of the first Denver St. Patrick's Day Parade in 1962 until his death in January 1986.

Jim was born in Denver and was a graduate of Regis College and the University of Denver Law School. During World War II, he was a Navy fighter pilot. He was Commander of the Leyden-Chiles-Wickersham Post No. !, Area Commander of the Legion's youth programs and President and National Director of the Denver Council of the Navy League. In 1969, he was awarded the national units Scroll of Honor and, in 1971, the Department of the Navy Citation for Meritorious Public Service. ☘

CHARLIE O'BRIEN, President, Jan. 1986-Nov. 1989, was a veteran in the world of public relations, promotions and community affairs. He was a member of the St. Patrick's Day Parade Committee for over 20 years. He also worked with the Central City Parade, the Freddie Steinberg Memorial, the Musicians Ball, just to mention a few. He was a member of the Denver Chamber of Commerce and several others in the Metropolitan area. After the death of Jim Eakins in January of 1986, Charlie was elected to take charge of the 1986 Parade. In 1987 Charlie was re-elected as President for the 1987 25th Anniversary Parade and remained its leader until his death in November 1989. ☘

JACK HORAN, current President of the Denver St. Patrick's Day Parade Committee, is a native Denverite whose family roots in the city date back to the 1870s. The Horan family have always been active in civic affairs, fraternal organizations, service and social clubs, hospice organizations, various charitable organizations and their church.

His great grandfather was a City Councilman from the large Irish population of the East Denver Fourth Ward from 1900-1924. His Uncle Neil is a retired Chief Judge of the Denver District Court and was one of the original members of the St. Patrick's Parade Committee. Jack's father served the city for 46 years, as a firefighter, of which 33 years as was Assistant Chief.

Jack is Vice President of Horan and McConaty Family Mortuaries. He and his wife, Valerie, have four children — John J., Michael, Deborah and Kathleen.

Jim Eakins, Charlie O'Brien, and Jack Horan were founding fathers of the St. Patrick's Day Parade, which they reestablished in 1963. Anti-immigrant, anti-Catholic sentiment had stopped the parade in the early 1900s. (Richard and Maureen Caldwell, Denver's St. Patrick's Day Parade Committee.)

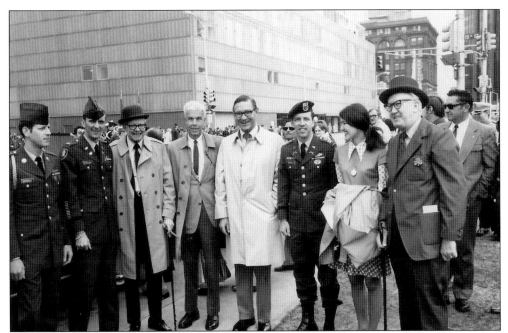

Mayor William H. "Bill" McNichols Jr., third from left, and Denver's US representative Patricia Schroeder, second from right, the city's top officials and both proud of their Celtic heritage, helped this committee promote the St. Patrick's Day Parade. (Richard and Maureen Caldwell, Denver's St. Patrick's Day Parade Committee.)

The City of Denver Pipe Band & Highland Dancers have become a mainstay of the parade commemorating the birthday of St. Patrick. Here, they warm up in Civic Center Park before the parade. (Thomas J. Noel collection.)

Leprechauns galore decorate the family-friendly St. Patrick's Day parade floats, blessing sidewalk audiences with tossed treats and smiles. (Richard and Maureen Caldwell, Denver's St. Patrick's Day Parade Committee.)

Even dogs, especially Irish wolfhounds, are welcome in Denver's all-inclusive St. Patrick's Day Parade. (Thomas J. Noel collection.)

Irish step dancers prance through the parade, which begins at Coors Field. (Visit Denver: The Convention & Visitors Bureau.)

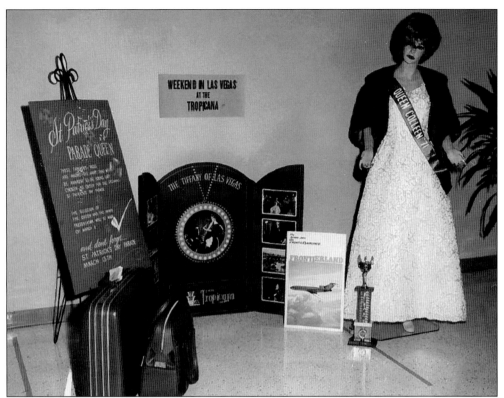

Queen Colleen in 1971 received all of these prizes and got to ride at the head of the St. Patrick's Day Parade. (Richard and Maureen Caldwell, Denver's St. Patrick's Day Parade.)

The Great Leadville Hibernian Mining & Marching Society cosponsors the St. Patrick's Practice Day Parade on the Saturday closest to September 17. Judge Neil Reynolds of the group explained that March 17 is freezing and snowy in the Two Mile High Cloud City, but September is usually sunny, warm, and golden with the turning of the aspen leaves—a perfect time to practice. (Thomas J. Noel collection.)

This 1995 St. Patrick's Practice Day Parade is led by Leadville municipal judge Neil Vincent Reynolds, second from right; Mayor Michael Kerrigan, third from right; and state senator Dennis Gallagher, fourth from right. (Thomas J. Noel collection.)

Leadville's St. Patrick's Practice Day Parade winds up in the Silver Dollar Saloon with entertainment from the City of Denver Pipe Band. (Thomas J. Noel collection.)

BIBLIOGRAPHY

Celtic Connection Denver. 1993–present.

Convery, William Joseph III. *Pride of the Rockies: The Life of Colorado's Premier Irish Patron, John Kernan Mullen.* Boulder, CO: University Press of Colorado, 2000.

Denver Catholic Register. August 11, 1905–present.

Emmons, David M. *Beyond the American Pale: The Irish in the West, 1845–1910.* Norman: University of Oklahoma Press, 2010.

Leonard, Stephen John. *Denver's Foreign Born Immigrants, 1859–1900.* Pamona, CA.: Claremont Graduate School and University, History PhD Dissertation, 1971.

Noel, Thomas J. *The City & The Saloon: Denver, 1858–1916.* Niwot: University Press of Colorado, 1996 reprint of 1982 University of Nebraska Press hardback edition and 1984 Bison Book paperback with new (1996) foreword on the neo-puritanical 1990s.

———. *Colorado Catholicism & The Archdiocese of Denver, 1857–1989.* Boulder, CO: University Press of Colorado, 1989.

Stewart, John C. *Thomas F. Walsh: Progressive Businessman and Colorado Mining Tycoon.* Boulder, CO: University Press of Colorado, 2007.

Walsh, James Patrick. *Michael Mooney and the Leadville Irish: Respectability and Resistance at 10,200 Feet, 1875–1900.* Boulder, CO: University of Colorado History Department, PhD Dissertation, 2010.

INDEX

Discover Thousands of Local History Books
Featuring Millions of Vintage Images

Arcadia Publishing, the leading local history publisher in the United States, is committed to making history accessible and meaningful through publishing books that celebrate and preserve the heritage of America's people and places.

Find more books like this at
www.arcadiapublishing.com

Search for your hometown history, your old stomping grounds, and even your favorite sports team.